Collecting Original Prints

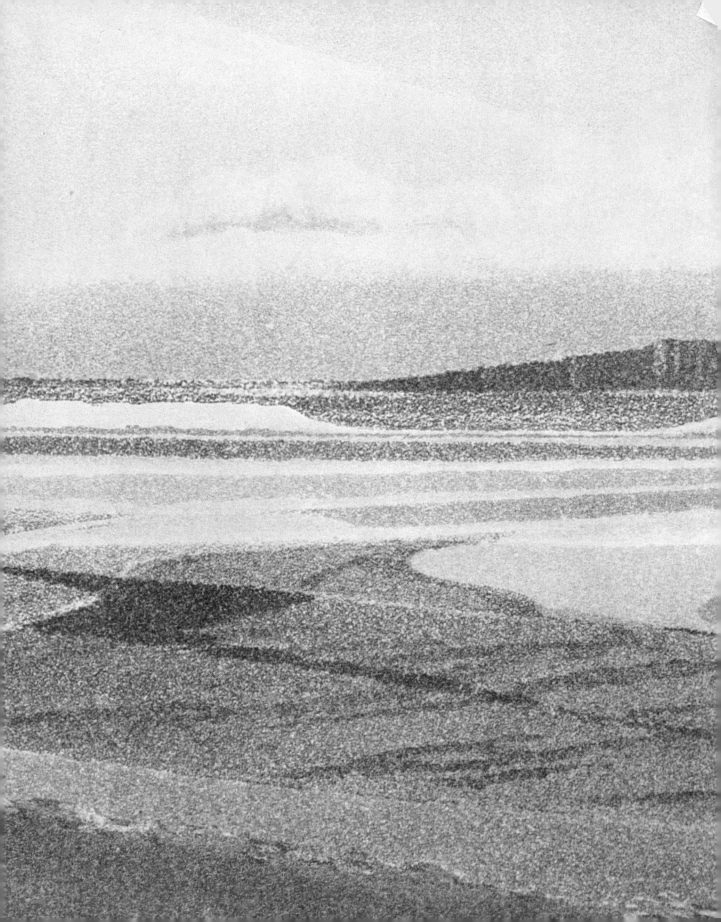

Collecting Original Prints

Rosemary Simmons

MAYFLOWER BOOKS · NEW YORK CITY
CHRISTIE'S INTERNATIONAL COLLECTORS SERIES

For Anthony H Christie

Title page: *Dunstanburgh Castle*, Michael
Fairclough, enlarged detail of colour aquatint
using two plates.

Library of Congress Cataloguing in Publication
Data
Simmons, Rosemary, 1932–
 Collecting original prints.

 (Christie's international collectors series)
 Bibliography: p.
 1. Prints – Collectors and collecting. I. Title.
II. Series.
NE885.S47 1980 769′.12 80–13723
ISBN 0–8317–1499–9

Manufactured in Hong Kong

First American edition 1980

Contents

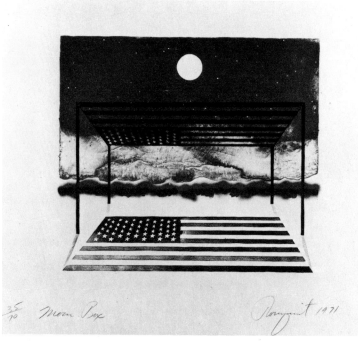

Moonbox, James Rosenquist, lithograph

Introduction

In writing *Collecting Original Prints* I have set out to clarify exactly what is meant by an 'original print' and to help the would-be collector to understand and appreciate the difference between the many kinds of prints available, as well as to enjoy looking at them. The difference between etching and engraving, lithograph and mezzotint as well as such technical terms as plate-marks, deckle edges and limited editions may well confuse the layman and I have therefore explained the various printmaking methods, illustrating each one with a contemporary example, as well as dealing with the papers used and the associated technology. There is also an extensive glossary.

The collector must also care for his prints, know how to conserve and frame them so that they do not become damaged or faded should he decide to re-sell. Prints are probably the most accessible form of modern art and where and how to buy and sell is an important factor in building up a collection.

Prints and printmaking have a fascinating and varied history, the most

ancient techniques still being used today, and the book thus begins with a brief survey of the historical development of this flexible and constantly changing art-form. The term 'original print' was not coined until the 1960s and its precise meaning is still not universally agreed. The definition that I have used, and which I discuss in greater depth at a later stage, is fairly loose and corresponds with the views of many working artists today. It is that an original print is a work conceived and originated by the artist as a print. This excludes all 'prints' which are reproductions of another work in another medium, such as a painting.

The world of prints and print collecting is not that complex or daunting and in this book I have tried to cover most aspects of interest to the collector, avoiding unnecessary technical detail and creating interesting visual comparisons. If, in the course of illustrating a point, I have used a small section of a print, thus changing the artist's intention, I hope I will be forgiven.

Snow Moon, Kathleen Caddick, detail of etching

Empress of India, Frank Stella, lithograph

7

Collecting prints

Putting a picture on a wall is one of the few purely personal decisions that can be taken today and one of some importance since the image you choose is one that you will probably live with for some time. Through the choice of pictures and ornaments the individual personality is expressed and fostered. Possession is an undeniable part of enjoying a work of art and the subtler forms and suggestions are revealed only slowly on closer acquaintance. There is something unique in owning a print which you have chosen. You are the other half of the equation: the artist creates a work from his imagination but it is not complete, not fully realized until it communicates the idea to someone else.

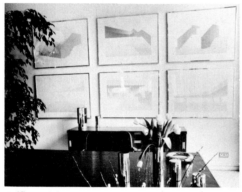

Office with prints

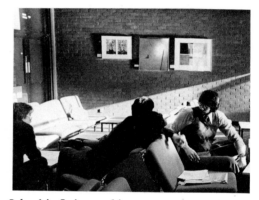

School in Leicestershire

Original prints are often seen today in public buildings. Many educational authorities have, for a number of years, adopted the admirable policy of buying prints to circulate around between their various buildings and many schemes have also been started to lend prints to the public in the same way as books. Executives of progressive companies are frequently allowed a choice of prints for their offices, while general selections are made for reception areas. Similar collections of prints can also be seen in banks, medical waiting rooms, hotels and restaurants.

The enormous range of printmaking techniques offers both artist and collector great variety; there is bound to be something to appeal to all tastes and suit every situation. The choice is extraordinarily diverse. The collector is offered prints of widely varying sizes, from the most traditional style to the very modern – with similarly disparate prices.

Print prices

There is a wider choice in terms of price in the print market than is possible when works of art exist only as single, unique pieces. A print can be bought from a student, subsidized of course by the provision of college equipment, very cheaply and one also has the satisfaction of fostering a new talent. Prints by acknowledged masters, whose unique works are generally seen only in museums, fetch a great deal more. The prices, however, are within reach of an enthusiastic print collector, unlike the same master's, say, oil paintings.

Not all prints should be taken too seriously. Some are ephemeral, often expressing very transitory ideas or social events. It is doubtful, for example, whether many of the 'transcendental' images produced by the flower children in the sixties are worth keeping. The inexpensiveness of prints is important in that it allows the collector to experiment and change his interests.

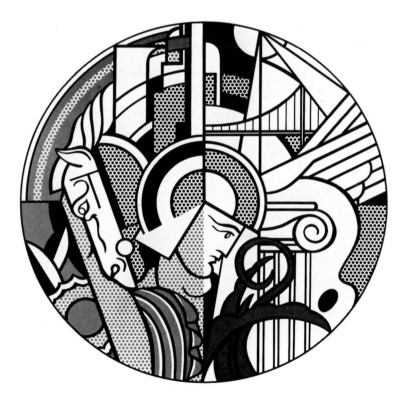

Poster for the Guggenheim Museum, Roy Lichtenstein

The internationalism of prints

Prints are easily rolled, put in a tube and posted or carried to other cities or other countries. Art has seldom been so mobile. This has been valuable to artists as much for the exchange of ideas as for the possibility of gaining an international reputation; something that would have been impossible if their work were solely available in the form of paintings. Artistic ideas have been disseminated surprisingly rapidly largely because of the portability of prints and this has contributed to their internationalism, so apparent at the large print biennales (print fairs held every other year) in America, Britain, Europe and Japan, though some countries with a strong graphic tradition such as Poland and Japan maintain their individuality, often more in technique than ideas. Artistic movements may start in one country, for example Pop Art began in Britain or America (art historians differ) but soon become current worldwide, partly due to prints.

Pictures from Finland, Summer, Raimo Kanerva, screenprint

The Ladder of Fire, Liliana Porter, etching with aquatint

left: *Processional Figure* after Maerten van Heemskerck, engraving
right: from *Ways and Means*, Allen Jones, screenprint

Prints past and present

The beginnings of printing

Printmaking has its roots in China, where, in the second century AD, rubbings from carved inscriptions are recorded. The Chinese also applied colour to carved seals which were stamped on a variety of materials. The most significant invention for printing, that of paper in 105 AD, also took place in China, whence it spread to Japan and along the trade routes to the West. Paper was first made in Europe in 1115 AD in Spain.

The demand for religious texts in China during the T'ang dynasty (618–906 AD) led to the development of the wood block, cut in relief, inked and burnished onto paper. Complete pages of text and illustrations carved from a single piece of wood were known as block books. By 1241 AD movable type moulded in ceramic had been developed in Korea.

Wood blocks were probably first used in the West to print patterns on fabric, but the solid-page block book was widespread by the fifteenth century and thousands of block prints of religious pictures, indulgences, popular tales and playing cards were available at shrines and fairs. Important books were still hand written by monastic scribes but although the demand for books was growing block books proved an almost equally slow method of production. How widely the Korean invention of movable type was known in Europe is uncertain; however Johann Gutenberg in Mainz brought together the skills of engraving and casting (he was a goldsmith) with a refinement of the wooden screw press, unknown in China, and an improved ink so that by 1450 he was able to print his famous '42-line Bible' with movable metal type. This breakthrough in producing texts relatively easily and cheaply aided the spread of literacy and by 1480 there were printing presses throughout Christian Europe.

In illustrated and decorated books the metal type was printed first and the embellished initials and pictures printed later from wood blocks, also called woodcuts. This method did not allow for much detailing and illustrators soon adopted the ancient techniques of engraving metal and etching it in acid. These highly developed skills were used to decorate armour, weapons and both household and church plate. Indeed goldsmiths and silversmiths sold patterns for copying in the form of prints taken by rubbing ink into incised designs in metal and pressing them on to paper. It was a short step to making illustrations for books in the same way though they still had to be printed separately from the metal type as they required different ink and different amounts of pressure.

The Censer, Martin Schongauer, engraving

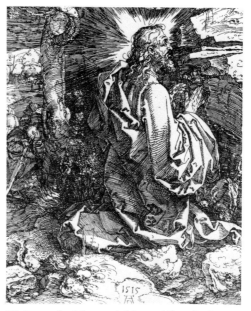

Christ on the Mount of Olives, Albrecht Durer, detail of etching

Illustration into art

Early prints, generally by anonymous artists, were used mostly to illustrate books and for devotional images. In the early sixteenth century prints came into their own as an independent art form with Albrecht Durer. As an apprentice he worked as one of the many artisans who produced over six hundred woodcuts to illustrate the *Nuremberg World Chronicle* of 1493. From 1498 Durer worked as an independent master, producing a large number of impressive woodcuts but he was searching for a technique which would permit finer detail than was possible on wood. Durer started copper engraving in 1497 and produced some of the earliest etchings in 1515. These works were no longer merely illustrations to accompany a text but were intended as individual prints and were acknowledged as outstanding works of art in their own right. Other important artists who made prints in the sixteenth and early seventeenth centuries include Altdorfer, Baldung, Cranach, Goltzius, Holbein the Younger, Schongauer and Van Leyden in Germany and the Low Countries, Callot in France and Italy, where Mantegna, Pollaiuolo and Parmigianino were also active.

The majority of printed images, up to the invention of photography, served primarily to educate or amuse. Generally they were not intended to be first and foremost works of art but often they have come to be regarded as such. Old maps are now treasured for their pictorial qualities and technique, rather than for their accuracy, and Hogarth is admired for the skill of his irreverent engravings, though only one of many visual satirists in eighteenth-century London.

The Italian Renaissance created an enormous demand for knowledge in Europe and woodcuts, metal engravings and etchings abounded on every subject: anatomy, botany, medicine, architecture and navigation. These sciences were all advanced by the exchange of ideas, many of them illustrated, in books and treatises. The sale of popular, illustrated song sheets, stories and calligraphic copying books also flourished. Designs for furniture and fashionable clothes were extremely successful and everywhere Christianity encouraged images of saints and miracles to reinforce the teachings of the Church. The value of printed pictures as a means of communicating ideas to a much larger audience than the printed word was soon recognized by politicians who tried to control seditious prints by insisting that both printer and artist must engrave their names below the image.

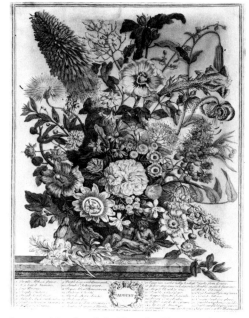

August, Months of the Year in Flowers after Casteels, engraving

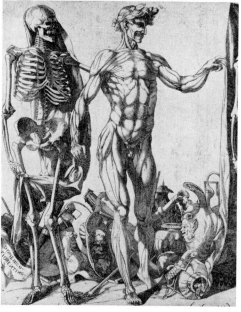

Squelettes et Ecorches, Domenico del Barbiere, detail of etching

The dissemination of artistic ideas

From the early sixteenth century famous paintings and occasionally sculpture were copied in the form of prints and the work of the famous Renaissance artists became known throughout Europe through these easily portable images. Many of the prints were anonymous and frequently inaccurate, however some of the engravers were skilful and their interpretations of these artists' work have always been highly regarded. Marcantonio Raimondi, born in Bologna in 1480, was such an engraver. He became very successful through his engravings after works by Raphael, Michelangelo, Durer and Titian. Raphael also employed his own engraver, as did Rubens later, to ensure that the engravings were accurate and did justice to the original work, wisely as Durer accused Raimondi of copying his works too closely and passing them off as his own. Goltzius (1558–1616), an engraver of great virtuosity, based his work on that of artists he admired, like Michelangelo, but although derivative his works cannot be regarded as merely reproductive.

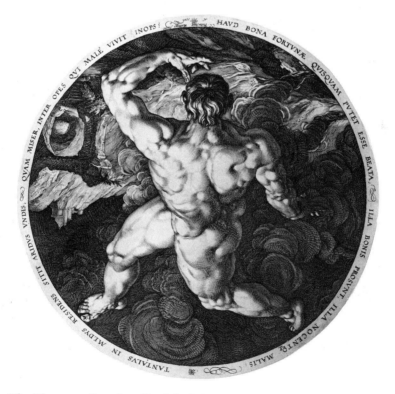

The Disgracers: Tantalus, Hendrik Goltzius after Cornelisz, engraving

The search for tonal expression

A further development of etching and engraving technique was required by both the copyist and the creative printmaker. A painting which was to be copied may have relied in the original on dramatic chiaroscuro (see glossary) so that a very wide tonal range was also required in the print. To create tone, or degrees of light and shade, the printmaker had to make use of an optical illusion – that black dots, hatching or similar marks close together create grey. Depending on whether the marks are large or small and on their density within an area, the tone of grey becomes darker or lighter. In etching and engraving tone could be achieved in a variety of ways: cross-hatching of lines, build up of dots or the thickening of lines were all used to create tone.

The basic aim in printing is to devise a means whereby the printing surface will 'hold' sufficient ink to transfer the image to the paper when printed. Both engraving (cutting into the metal) and etching (using acid to bite into it) can be done to different depths and so hold a greater or lesser amount of ink. When looking at such prints it is useful to have a magnifying glass, not only to check details, but to understand how the artist has created and used tone.

Galatea, Hendrik Goltzius, chiaroscuro woodcut

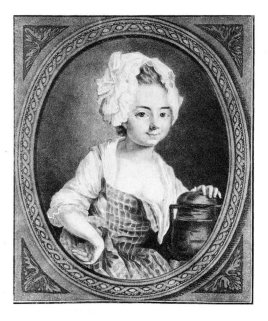

The Milk Woman, Louis Marin Bonnet, stipple engraving in the crayon manner

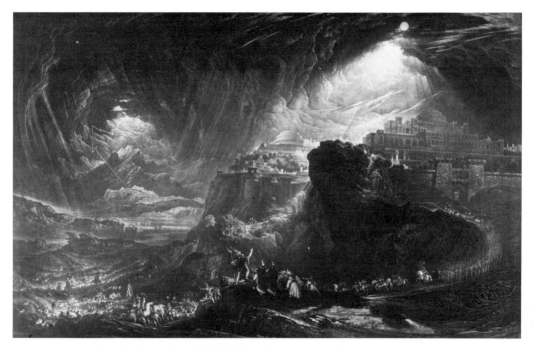

Joshua Commanding the Sun to Stand Still, John Martin, mezzotint

The creative artist, engraving or etching his own plates, was equally interested in obtaining the widest possible range of tones. Rembrandt reached unsurpassed heights of expression and tonal contrast, but in the hands of lesser artists the rendering of tone by means of lines and dots was frequently formalized and pedestrian.

Chiaroscuro woodcuts were one answer to the problem and were the forerunners of multi-coloured printing. Lucas Cranach in sixteenth-century Saxony cut extra wood blocks which were printed over the original design in light tints to supplement and thus extend the tonal range. Hendrik Goltzius perfected the technique, using four blocks to build up the design. The white of the paper constituted the highlights and the blocks were printed in four shades of brown or sometimes grey, from light to dark.

There was also considerable demand for ways of imitating the greater freedom of crayon or pencil drawings. Eighteenth century engravings 'in the crayon manner' were very convincing in the hands of artists such as Demarteau and Bonnet. Of much greater importance, however, in the search for increased tonality was the development of mezzotint and aquatint. Mezzotint was invented in Holland in 1609 by Ludwig van Seigen and later developed by Prince Rupert of the Rhine, who took it to England, where it became so

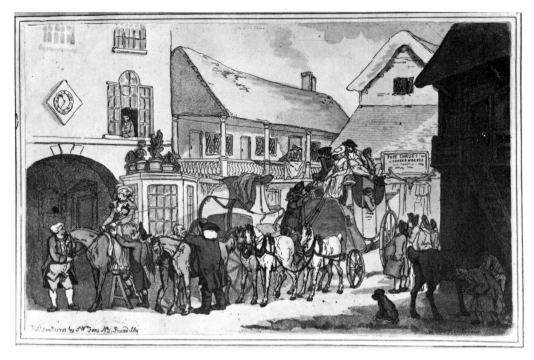

The Stage Coach, Thomas Rowlandson, etching with aquatint

popular that it was called 'the English manner'. Mezzotint is a variant of engraving which permits very deep, velvety blacks and an infinite range of tones up to pure white. It was widely used for portraits and reproductions but few creative artists were inspired by it until the mid-twentieth century. The origins of aquatint are uncertain but it was revived and refined by Le Prince and other artists in France around 1760. It spread rapidly to all parts of Europe and was used by both creative artists and copyists. Aquatint is a variation of the etching technique and because the design is drawn with a brush, rather than the sharp point used to make a line etching, the general effect is similar to a wash drawing. It is often used in conjunction with line etching, when the main design is described in line and the aquatint contributes tones of grey. The actual making of an aquatint is far less arduous and time consuming than a mezzotint but it cannot achieve the same richness of tones, particularly in the deepest blacks. Artists, however, relished the freedom which aquatint offered and used it with skill and imagination to create some of the finest prints in any medium. It proved to be a more flexible technique than mezzotint and as a result became more popular.

18

Function and creation

Prints became enormously popular during the seventeenth and eighteenth centuries and as communications improved print publishers became successful businessmen all over Europe. It was common for the publishers to buy the completed plate from the artist and then print from it to suit demand. Editions and signatures were then unknown, so popular plates were printed until they wore down and then they were frequently re-engraved to strengthen the lines. For this reason prices may vary greatly for the same print by artists such as Rembrandt and Goya, depending on the condition of the plate when the print was pulled.

Many artists allowed their paintings to be copied and when these prints are of the quality of David Lucas's mezzotints after Constable, done during the early nineteenth century, they are worth collecting in their own right. It must be admitted, however, that many of the thousands of topographical views, sailing boats, exotic places, flowers and birds are of a quite different calibre and can be regarded in much the same light as postcards today.

Stoke by Neyland, Lucas after Constable, detail of mezzotint

Canton de Basle, Birman after Himeley, detail of aquatint

19

The Old Masters

Rembrandt, among all the masters of etching, is of special interest to the collector of modern prints. He was in the habit of working on some plates for a long time, after each modification he took a print – the state – to gauge the effect of the changes. By looking at the various states of certain prints, the development of the artist's idea can be traced. Rembrandt's attitude to experimentation, changing the emphasis on various parts of the print and using the medium to express the theme, are close to the ideas held today. His most famous prints such as *Christ Healing the Sick*, finished in 1649 and known as *The Hundred Guilder Print*, such was the demand for it, went through many states. Most prints are known to us only in their final, polished form, so that seeing Rembrandt's states reveals the extensive reworking and refining of the original idea necessary to produce a satisfying image.

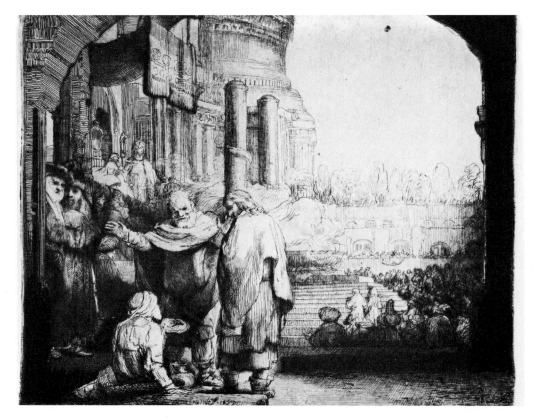

Peter and John, Rembrandt van Rijn, etching, drypoint and engraving

20

In France, Louis XIV and his courtiers were great patrons of the arts. Cardinal Mazarin was reputed to have had a collection of one hundred and twenty thousand prints by about 1660, which later became the nucleus of the largest collection of prints in the world, now housed in the Bibliothèque Nationale in Paris. Eighteenth-century artists such as Watteau and Fragonard also made important contributions with their etchings. In Italy at roughly the same time, Tiepolo and Caneletto made many etchings; however it is Piranesi whom we tend to most appreciate today, especially his series of large, dramatic etchings of fantastic prisons.

In Britain at this time, Hogarth made a number of prints after his own paintings and Rowlandson was largely known through his witty, satirical aquatints. Turner's mezzotints of landscapes and the sea are masterpieces; Gainsborough too did delightful soft ground etchings (see glossary) of landscape and Alexander Cozens developed lift ground aquatints (see glossary). Blake has a special place in the story of printmaking for his curious mixed techniques.

Spain produced a master comparable to Rembrandt in Goya, whose etchings with aquatint and pure aquatints remain some of the most impressive creations in any medium.

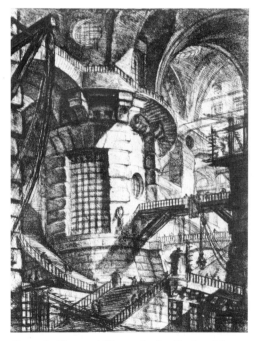

Carceri, Giovanni Piranesi, detail of etching

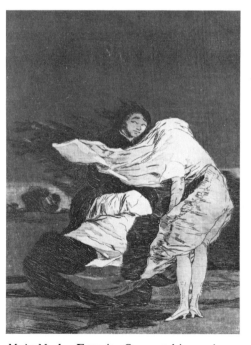

Mala Noche, Franciso Goya, etching and aquatint

Lithography

The invention, by Alois Senefelder in Bavaria in 1789, of an entirely new way of printing was to provide artists with a marvellously rich and different medium, though it took a century for it to develop fully. Senefelder spent much of his life experimenting, trying to devise cheap and reliable ways of printing. Initially he was looking for means to print the text of his own plays. He experimented with variations on the etching technique using slabs of stone as a cheap substitute for copper. By chance he discovered the principle of lithography (lithos being the Greek for stone and graphos for drawing) and his wide experience in other forms of printing gave him the necessary background to devise a sound working method and to invent a special press.

Senefelder called it 'chemical printing' since it is based on the antipathy of grease and water and does not involve cutting into the plate, as with copper or wood. The fine quality Bavarian limestone which Senefelder used is still considered the best, although it has now been largely replaced by metal sheets. He took his invention to London and by 1803 lithographs by Fuseli, Nollekens and Benjamin West had been published.

In America, the first lithographic press was set up in 1818 and the technique was rapidly adopted across the States. Posters flourished, with artists such as Penfold and firms like Currier and Ives in New York employed hundreds of artists to draw lithographs of every conceivable subject from sporting events, accidents and topography to the Indian tribes.

The colour explosion

The demand for colour prints could not be satisfied until lithography became widely available. Multi-block woodcuts were tedious to cut and multi-plate etchings and engravings were equally time consuming and expensive to make. Some coloured aquatints were done with two plates and had patches of colour applied to the plate by hand before printing but this was a slow and skilful process. Most prints were monochrome and later hand-coloured with watercolour. Lithography also offered the possibility of much larger scale, since stones could be four feet or more in length and the raw material was cheap.

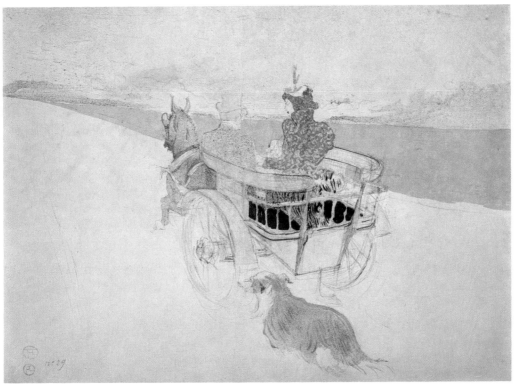

The Pony Trap Henri de Toulouse-Lautrec, lithograph

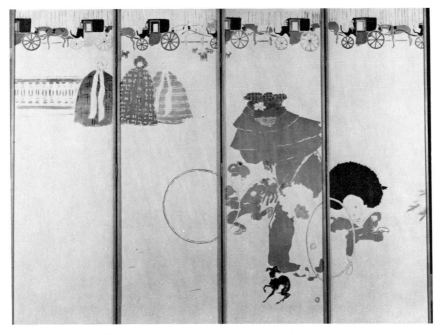

Frises des Fiacres, Pierre Bonnard lithograph in screen form

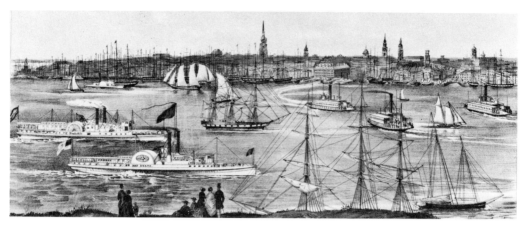

View of New York published by Currier and Ives, detail of lithograph

Early lithographs imitated drawings and it was some time before artists grasped the full range of its possibilities. In France, Goya (exiled from Spain in 1822), Delacroix, Gericault and Daumier produced some impressive black and white lithographs, enhancing the medium's reputation as an artistic technique. Later, Manet encouraged the Impressionists to try lithography. Commercial demands for large, colour posters ushered in the era of the great poster artists: Toulouse-Lautrec, Cheret, Steinlen and later Mucha. As lithographic artists Degas, Vuillard and Bonnard have never been equalled; rarely using more than five colours they created superb graphic designs.

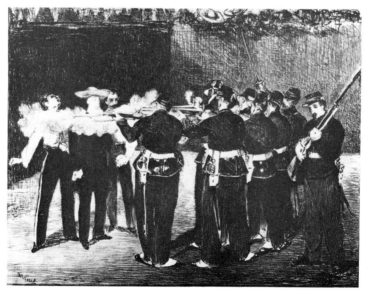

L'Execution de Maximilian, Edouard Manet, lithograph

24

Illustration

In France lithography was widely adopted by illustrators. Daumier produced four thousand lithographic illustrations for *Le Charivari* and *La Caricature* for which he is justly famous. British illustrators tended to prefer wood engravings. Engraving on the end-grain of box wood had been used for fabric printing blocks but was not taken up by illustrators until Thomas Bewick (1754–1828) realized the potential of the very fine grain of the wood which permitted greater detail than the traditional woodcut. In addition wood engravings could be printed side by side with type-matter, which made it economical for journals, catalogues and illustrated books. For speed large blocks were engraved in sections by several artisans and reassembled for printing. By the mid-nineteenth century it had deteriorated into a purely reproductive technique, even if it still displayed technical virtuosity.

The Disaster on board The Great Eastern, 1862, anonymous, wood engraving

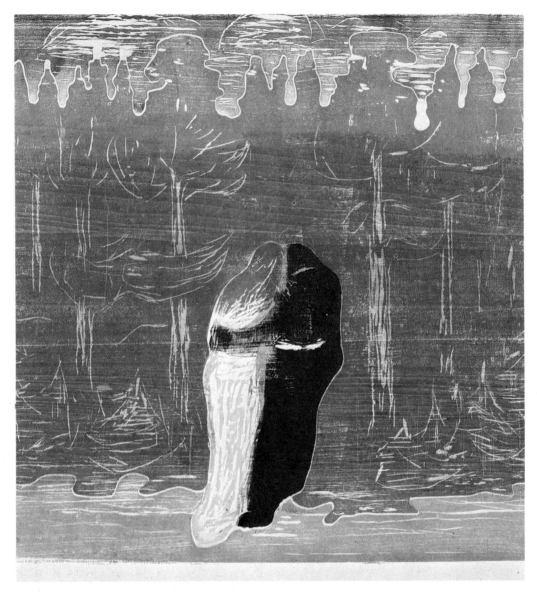

Zum Walde, Edvard Munch, detail of woodcut

The revival of the woodcut

Paul Gauguin's bold, innovatory designs cut in rough plank wood during his stay in Tahiti in the 1890s caused many artists to reconsider the woodcut as a medium. Edvard Munch (1863–1944) was one of these. He believed that it was essential to control the making of the print throughout the whole process and not to allow technicians to intervene. Munch experimented with colour, sometimes cutting up a block like a jigsaw and colouring each part differently or brushing colour onto different parts. Both methods produced multi-coloured prints from a single block. Especially interesting are his alternative colour versions produced from the same block.

In Germany a group of artists who called themselves *Die Brücke* (The Bridge), founded in 1905 as a protest against dry academism, favoured the woodcut for graphic work and included artists like Kirchner, Schmidt-Rottluff and Nolde.

Nave, Nave Fenua, Paul Gauguin, woodcut

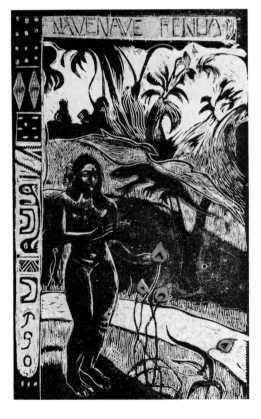

Blonde Frau, Emil Nolde, woodcut

27

Expressionism, Abstraction and Cubism

The German art movement which followed *Die Brücke* and which is generally known as Expressionism, included such artists as Marc, Beckmann and later Barlach and Kollwitz who preferred the woodcut for its vigour. The strokes of the cutting knife and gouge were exaggerated to convey passion and power in each mark. The non-image areas on the wood block were cleared roughly, leaving ridges and irregular shapes which picked up ink in a random fashion and contributed to the impression that the block was cut rapidly in a fever of inspiration. These woodcuts were often about people: portraits, interiors of nightclubs, theatres, shops and stations, building sites and streets bustling with activity. Many were pervaded by a bitter sense of social protest.

Two other important artists using wood, though in very different ways, were Felix Vallotton, a Swiss artist, whose rather decorative groups of people belong more to the Paris of the 1890s; and Maurits Escher, a Dutch artist, whose optical puzzles are still very popular.

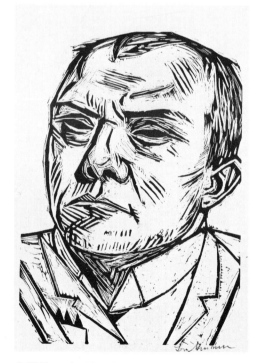

Self Portrait, Max Beckmann, woodcut

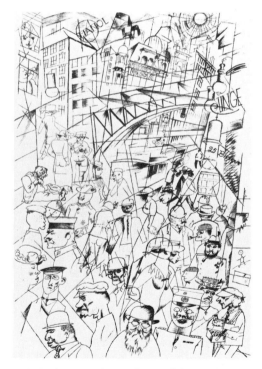

Friedrichstrasse, Georg Grosz, lithograph

Kandinsky and Marc formed the *Blaue Reiter* (Blue Rider) group in Munich in 1909 and they were later joined by Klee, Arp and Feininger, who, in their printmaking, all favoured the woodcut in the search for pure form. They used it mainly to experiment with the juxtaposition of flat areas of colour, testing the visual tensions created when one vibrant colour approaches the edge of another. Their work was not always abstract and they worked extensively in other media.

Abstract artists in Russia, just after the revolution of 1917, adopted the woodcut and lithograph as means of disseminating their ideas. Malevich, Rodchenko and Tatlin made powerful yet simple woodcuts, whereas El Lissitsky, Archipenko and Larionov preferred lithography, as did Kandinsky while in Russia. Their work was considered too iconoclastic and intellectual, out of step with the social realism which the new Communist regime favoured, but in the West it had a profound effect on artists such as the Dada group in Zurich.

Artists at this time did not confine themselves to any one graphic medium. Käthe Kollwitz, famous for her compassionate records of the poor, old and downtrodden in Europe between the two World Wars, is an equally great lithographer, etcher or woodcut artist. Georg Grosz in Berlin combined the graphic effects of etched, engraved and drypoint line in his intaglio plates and satirized society also in his woodcuts and lithographs.

The beginning of the twentieth century saw improved communications which enabled artists to travel easily throughout Europe. There was an increased exchange of ideas and the end of the traditional training of artists which demanded the painstaking learning of techniques. Instead they turned their hands to whatever medium seemed to promote their idea best. For this reason some of the lithographs of El Lissitsky or Kandinsky are technically indifferent. It was artists such as these who broke the stranglehold of the professional engraver and lithographer in their determination to reach a wider public with the new ideas of the Modern Movement.

In all forms of printmaking the artist has to make positive decisions. It is never as easy to make alterations to a print as to, say, a drawing or oil painting. When this decisiveness is practised by artists such as the Cubists, who had an exciting new theory to propound, powerful prints result. Some of the best early Cubist works by Braque and Picasso, made around 1911, were line etchings. The opposite attitude makes itself equally clear: indecision and lack of clarity in the artist's mind as to the exact formulation of the idea will not create an incisive image.

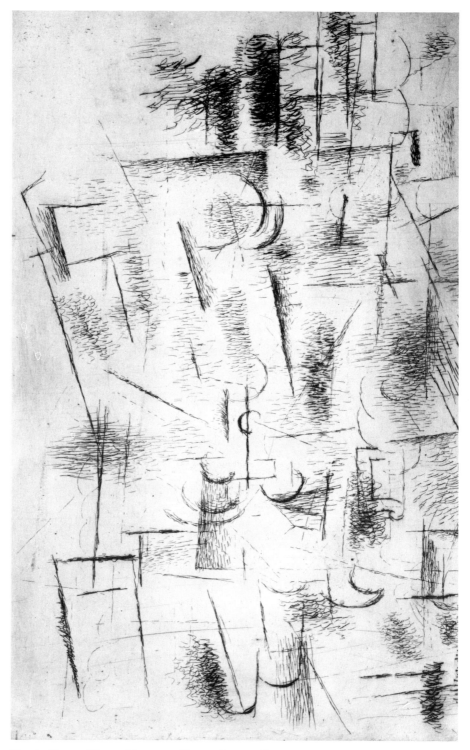

Composition en Nature Morte aux Verres, Georges Braque, etching

Ecole de Paris

Paris between the wars was the international centre of the art world and printmaking flourished there on an unprecedented scale. The majority of artists working in Paris made prints and many found it a stimulating means of expression: the etchings of Picasso, the lithographs of Matisse, Bonnard, Braque, Miro and Chagall and the colour aquatints of Rouault. Much of this activity was fostered by now famous publishers and dealers like Vollard and Kahnweiler. Studios devoted to making editions of artist's prints, such as Mourlot's lithographic workshop and Lacourière's etching studio, were very influential and promoted a standard of technical excellence with which contemporary printmaking still has to compete. The studios which now flourish in Britain and America have all been based on the French originals.

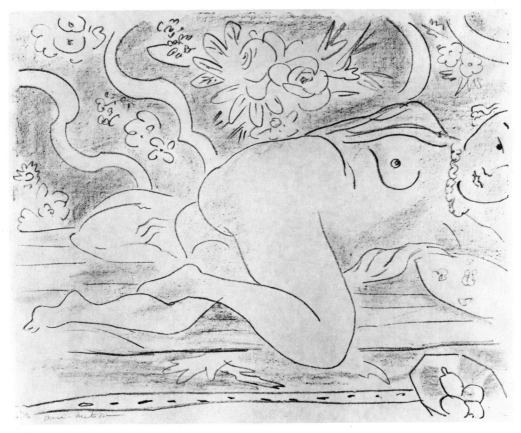

Nu Allongé a la Coupe de Fruits, Henri Matisse, lithograph

Britain and America

Visiting British and American artists knew of the artistic activity in Paris but although the Impressionists influenced their painting, their printmaking remained traditional. Monochrome etchings of landscape, architecture and domestic scenes were very popular on both sides of the Atlantic but curiously, especially since the printing of colour lithographs was first developed in London by Shotter Boys in the 1830s, colour lithography was virtually unknown. Work by etchers of the calibre of Whistler, an American living in London, Seymour Haden and McBey was much in demand and commanded very high prices until the collapse of the stock market in 1929. British artists of the twenties and thirties tended towards surrealism and in printmaking were responsible for a revival of wood engraving; Nash, Gill and Ravilious especially being important in this field.

The isolation of America during the Depression and the desire to avoid European involvement promoted a range of disparate, if distinctly American, styles from the traditonal etchings and lithographs of Hopper and Bellows to the Expressionist-influenced Marin and the freer styles of Davies and Davis. The Federal Arts Project, set up in America during the thirties, sponsored much printmaking, including early screenprinting, and gave rise to the emergence of a recognizable American School.

New York from Governor's Island, Walter Pach, detail of etching

Georges Braque, *L'Oiseau Traversant le Nuage*, lithograph

Post-war renaissance of printmaking

The printmaking workshops in Paris revived quickly after 1945 and resumed almost where they had left off with a stream of lithographs, etchings, wood and linocuts by Picasso, Braque and Chagall as well as the new generation of artists such as Corneille and Masson. The flood of images was marketed internationally; at the same time several doubtful practices became common, plates were made by skilful copyists but were signed by the artist himself and several editions of the same print were often published. Prints which had been completed just before 1939 but whose publication had been interrupted by the war were rediscovered. *The Vollard Suite* by Picasso suffered this fate and was finally published only in 1950. The print galleries which opened in Britain and America at this time, showed mainly French prints but encouraged indigenous artists to make prints and a number of printmaking studios opened which were modelled on the French workshops. The work produced also looked to Paris for its inspiration although younger artists were becoming resentful of Paris's domination of the art world. In America, and elsewhere, new movements and, naturally, new forms of printmaking were developing.

The print boom: Pop and Op art

The tremendous growth of printmaking during the 1960s has been called a print boom, implying a possible end to the enthusiasm but although there have been temporary fluctuations in public demand as successive waves of inflation and depression have their effect, there is still widespread and genuine interest in this art form which goes beyond considerations of investment and value. There is no doubt that printmaking is the art form most in harmony with our times.

The most modern method of printmaking, screenprinting, gained acceptance during the print boom. Fundamentally it is a sophisticated form of stencilling, which was developed during the early part of the twentieth century for the commercial printing of posters. Some artists experimented with screenprinting between the wars but it was the improved materials developed after 1945 which made it ideal for the intense and solid areas of colour required by the Op (Optical) and 'hard-edge' artists and the photographically based images of the Pop artists. As a new technique, unencumbered by historical precedent, screenprinting was psychologically attractive to artists breaking away from the influence of Paris. Artists such as Rauschenberg and Rosenquist used lithography as well but few used the traditional methods of etching or woodcut; screenprinting was paramount.

Untitled, Victor Vasarely, screenprint

34

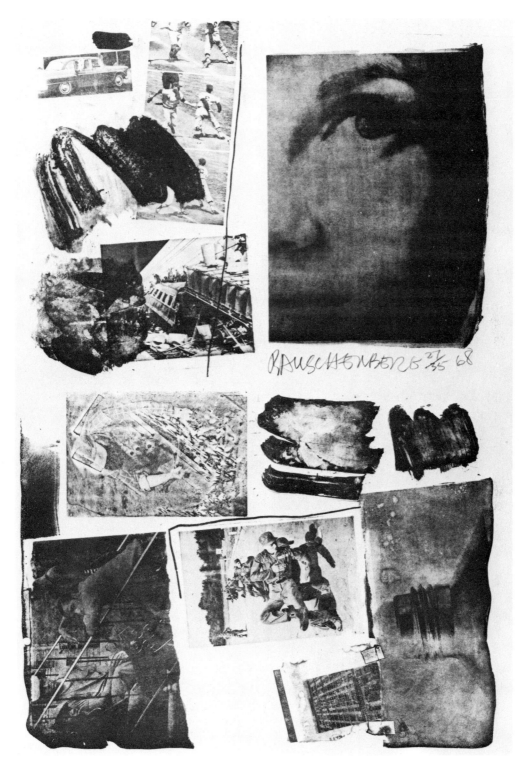

Pledge, Robert Rauschenberg, lithograph

New materials

The lure of experimenting with newly developed materials and techniques has threatened to engulf many printmakers and some very unremarkable prints have been created in the name of experiment. The only criterion which can be applied in the use of any materials or methods, old or new, is whether it enhances the idea or image the artist is conveying. If printing on transparent plastic conveys a special idea, such as of space perhaps, rather better than on paper it might be justified. If a sequential movement of a line, which has to obey very complex rules, can be better plotted with the aid of a computer and the result is more convincing than the same theme done by hand from the imagination then it may be preferable.

Images have been printed on every possible surface – flat or three dimensional – whether plastic, metal, ceramic or fabric. Prints have incorporated embossing, collage, flocking and metallic film blocking and have been of every shape; circular, square or irregular. Many of these prints will, unfortunately, be ephemeral as the materials used are untested as to how they will alter with the passage of time.

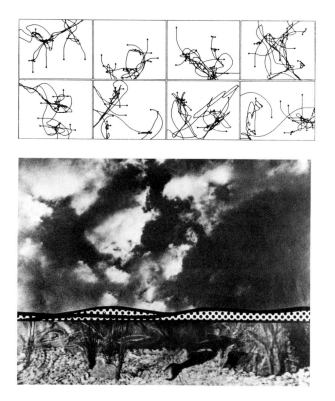

above left: *Untitled*, Chris Briscoe, computer/photo-litho

left: *Fishes*, Roy Lichtenstein, photo-litho, screen and collage of plastic

above: *4.35pm 25.11.1977*, Stuart Brisley, x-ray/photo-litho

Printmaking now

Today we seem to be going through a period of consolidation of new techniques and reassessment of traditional methods. Since 1970 there has been a marked return to intaglio prints and occasionally to lithography. Many artists became dissatisfied with screenprinting, particularly those who worked out their ideas through the cutting, rubbing or drawing of the plate or block. Screenprinting, or at least the method generally practised, implies a fully fledged idea from the start, whereas intaglio tends to build an image gradually. It is interesting that the slowest and most painstaking method, mezzotint, has seen a dramatic resurgence during the late seventies. There has been a conscious return to manual techniques as opposed to mechanical ones; even the use made of photographic images has changed. Commercial techniques have been abandoned and instead plates and screens have been meticulously prepared by hand in a super-realistic style.

Aleph, Bartolomeo dos Santos, etching and aquatint

Bestianus Domesticus: Lepus Cuniculus, Bengt Bockman, detail from lithograph

Bedtime Blues, Anne-Marie Le Quesne, linocut

Printmaking is often eclectic, sometimes to the point of total confusion. Every new movement spawned by rapid cultural change is reflected in print-making. Every taste and enthusiasm can be found in graphic form. Now that artists' prints have shaken off the slight of being thought merely a poor imitation of fine art and no longer need defending against such criticism, they can be appreciated as creative works and be assessed accordingly.

Many artists now work exclusively in the printmaking media, as opposed to painters who occasionally make a print, and this new generation of artists thinks in graphic terms. Inventive and independent, they often prefer to do their own printing rather than accept the necessary constraints which apply when working in a professional printmaking studio. They can also work in ways which are considered uneconomical in a more formal situation. These printmakers seldom become household names because they rarely fit into established promotional systems and are not newsworthy but their work is seen in the catalogues of the more imaginative print publishers and they are exhibited widely in the smaller galleries, particularly the specialist print galleries. Prices for their work are usually reasonable and they represent the real strength of contemporary printmaking.

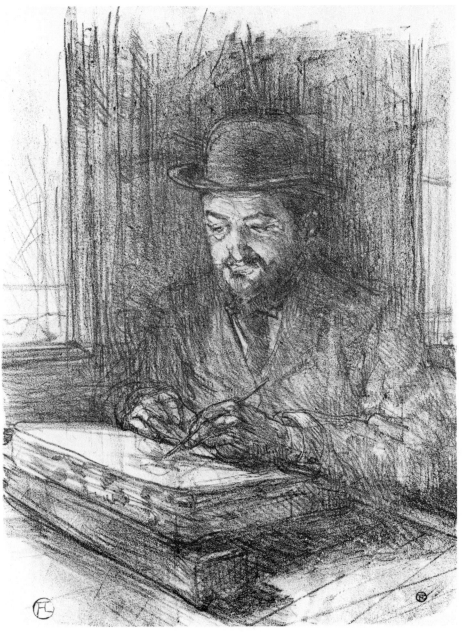

Le Bon Graveur, Henri de Toulouse-Lautrec, lithograph

Why do artists make prints?

The democratic art

The reasons artists give for producing prints, rather than another art form, fall mainly into two broad categories. Many artists genuinely want to communicate with a wider public and most find the techniques involved contribute a vital element to the expression of their ideas.

Looking at the art scene as a whole, the decline of private patronage continues and there is no satisfactory substitute. Artists have looked for new ways to relate to individuals who care for art but who are not collectors in the traditional sense. Painting and sculpture are only too often associated with museums, cathedrals and palaces, and a more informal, even ephemeral art form is better suited to the mood of the late twentieth century. In addition an image that exists in multiple form can be sold cheaply and from several outlets.

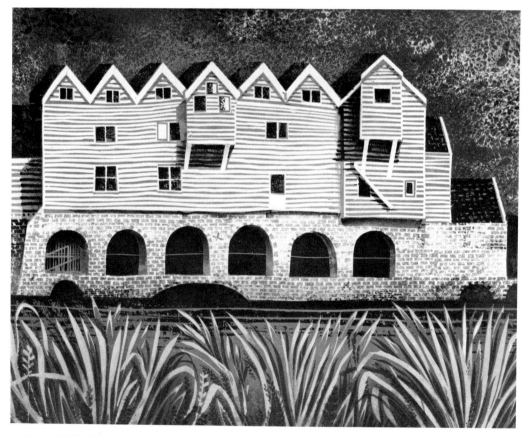

Coltishall Mill, David Gentleman, unlimited edition lithograph

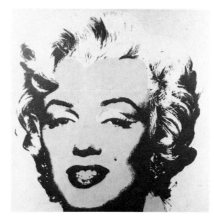

Joanna posing for Redfern, Paul Wunderlich, lithograph

Marilyn Monroe, Andy Warhol, screenprint

The attraction of the individual printmaking techniques is very real for the artist. There is considerable magic in the printing process itself; putting a virgin sheet of paper onto the plate, the physical effort of applying pressure to transfer the ink on the plate onto the paper and then peeling off the paper to reveal the design are in themselves exciting.

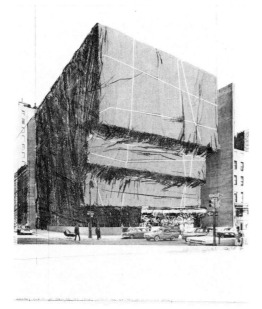

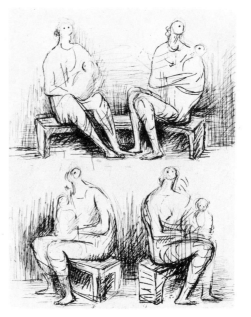

Whitney Museum of Art, Packaged, Christo, mixed media with collage

Four Mothers, Henry Moore, lithograph

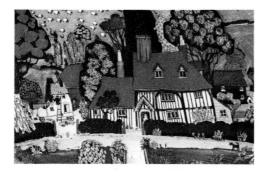 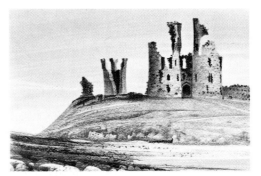

Old Manor, Graham Clarke, handcoloured
aquatint, *detail*

Dunstanburgh Castle, David Gentleman,
lithograph, *detail*

Even if the same action is repeated with a hundred sheets of paper for an edition the magic is still there. The physical involvement in both preparing the printing surface and the actual printing of the edition is an essential part of the creative process for many artists. Other artists prefer not to do the editioning themselves; to them the repetition is a pointless waste of their energy and the excitement lies in the initial proofing stage, the choice of paper and the position of the print on the sheet. Some artists have been, frankly, lazy and left too much to a master printer or technician in the belief that the initial idea is the only matter of importance and its manufacture is irrelevant to them.

Some artists welcome the discipline required to make a print and deliber-ately seek it in order to force themselves to clarify a train of thought or a half-resolved idea. Yet others find that effects of line or colour are possible only in the print media. Finally, there is the advantage of being able to proof an image in a variety of colour and paper combinations without making any changes to the master image on the plate, block or screen.

These diverse attitudes exist side by side but obviously some have greater sway under different circumstances. The screenprints of the sixties and seventies deliberately emphasized a mechanical effect – unadulterated by the personal touch of the artist. This was preceeded by a 'hand printed by the artist alone' movement, to which there has been some return recently. Experiment alternates with tradition: the public ask for larger and larger prints and then for small ones; monochrome prints are collected and then colour prints. The print world is lively and ever-changing with a hard core of tradition. The artist's response to public demand in turn initiates new ideas as collectors and artists of the same generation share certain feelings and attitudes.

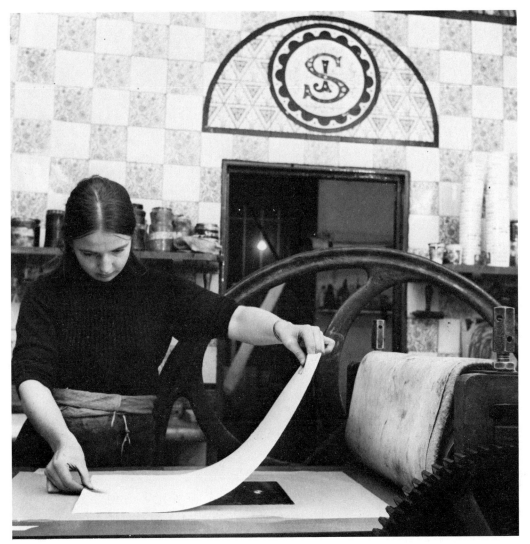

Dorothea Wight at Studio Prints laying the paper on an etched plate on the bed of the press

How prints are made

The four basic printing methods

Printing methods can be divided into four main categories in order of historical development: relief, intaglio, lithography and screenprinting. Sometimes the last two are grouped together under the general heading of planographic. There is some logic in this as the first two categories also describe the physical plane of the ink-holding image.

Relief includes all blocks (wood, lino, board) and plates (metal) in which the ink-holding image is in relief or raised above the surface (see pages 45–46, 60–62). Intaglio, derived from the Italian verb to incise, covers all methods in which the ink-holding image is below the surface (see pages 48–49, 62–67). Lithography utilizes the antipathy between grease and water: the image is held on the surface of the plate, which is uncut (see pages 51–53, 68–69). In screenprinting the ink is pushed through the mesh of stretched fabric, parts of which are sealed by a stencil (see pages 54–56, 70–72). When several methods are combined in one print these are called mixed-media prints (see page 58–59).

Progress and tradition

Various other techniques are being used by artists under the blanket term 'print'. One technique which is now often seen in print exhibitions is photography (see page 57). Computer printouts are sometimes shown in the form of photo-litho (see page 68) or photo-screen (see page 70) prints. One invention which is now being used by artists and shows signs of increasing popularity as the mechanism is improved, is that of electro-static printing which is commonly known under the trade name of Xerox (see glossary). Other office and plan copying printing machines such as small offset-litho and stencilling machines are also used.

These commercial methods are enticing but since they are developed for unskilled supervision the artist usually reaches a point beyond which he cannot intervene in the process nor can he push the machine beyond the restricted task for which it was designed. The revival of interest in traditional manual techniques is largely because the newer methods are so unsubtle by comparison, they do not permit alterations and corrections and, where they use colour, the effect is very limited.

Relief printing

The printing block has the image in relief: all the non-printing parts must be cut away. Colour is applied to the design by a pad or roller. Paper is then laid on the inked block and pressure applied by means of a press or by burnishing (rubbing) the back of the paper. When the paper is lifted the ink has been transferred to it from the block.

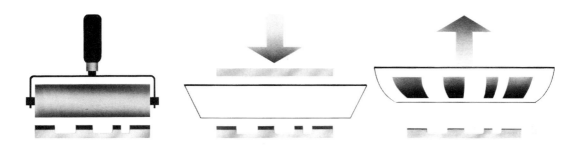

Relief printing blocks can be made from any flat material, the most common being wood (see pages 60 and 62). Lino is also widely used (see page 61). Other flat materials such as card, board and metal and plastic sheets are also used (see page 61). Blocks can also be made by gluing flat objects onto a backing board (see page 61).

Common tools, such as knives and chisels, are used to cut away the non-printing material from blocks, leaving a raised surface to carry the ink. Sometimes special tools are required, such as the graver used on end-grain wood blocks. Metal plates for relief printing can also be engraved but are usually made by etching in acid.

Alterations to blocks are difficult so the design has to be carefully planned, it has also to be cut in reverse so that, when it is printed, it reads the right way. Normally one block is cut for each colour but if colours are sufficiently separated several can be put on one block by means of small rollers or dabbers. The ink is usually oil-based, though Japanese wood block prints use water-based colours. Soft paper (paper not treated with size or glue) takes the relief impression best. Presses vary from old nineteenth-century models to newly-made machines and from table-top models which can print small wood engravings to those which can print a sheet of paper thirty by forty inches. Burnishing is done with a circular pad such as the Japanese baren (see glossary) or the back of a wooden spoon.

Characteristics of relief prints

In general relief prints are bold, the lines and edges of patches of colour are crisp and they rely more on colour than drawing. The grain of the woods used for woodcuts are coarse and therefore the cutting has to be bold. The grain pattern is often emphasized by wire-brushing and weathered woods are specially selected for their natural patterns. Wood engraving, which is usually printed in black on white, exploits the very fine line which can be cut in end-grain wood blocks.

Lino is softer to cut than wood so the incisions are freer and more flexible in direction. Large, flat areas of colour print very evenly from lino as it has no perceptible texture, though it can be etched to give a grainy surface. Card and board also print areas of flat colour well, though other boards, such as corrugated paper, may be inked and printed to give their own characteristic textures. Uneven surfaces, such as leaves, will print the thicker parts only unless soft padding is used between the paper and pressure source.

Japanese artists shade colours by *bokashi*, using the capillary structure of the wood to blend two colours in the direction of the wood grain. Western artists achieve a similar effect by blending colours with a roller before application to the block. Usually, though, tone is suggested by finer or coarser cutting and texture. Burnished prints often show through to the back of the paper.

Terms associated with relief prints

Relief prints are also called surface prints. The material of the block gives its name to the subdivision of the genre: wood-cut, wood-engraving; lino-cut, lino-engraving, lino-etching; hardboard or masonite-cut; card or cardboard-cut; Perspex or Plexiglas-cut. The term 'white line' describes a design predominantly white on black and is mainly associated with wood-engraving. Relief etchings are made from metal plates etched in acid but surface (instead of intaglio) printed (see page 48). Letterpress is the general term for commercial relief printing from metal type and blocks (see line blocks and process engraving in the glossary).

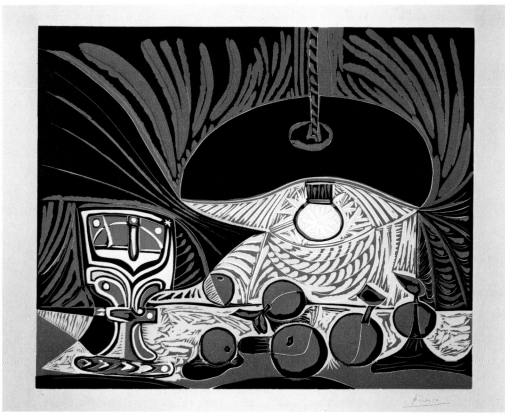

Nature Morte sous la Lampe, Pablo Picasso, linocut

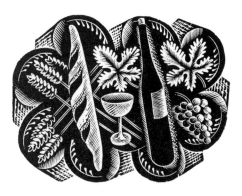

Decoration by Eric Ravilious, wood engraving

Intaglio printing

The printing plate has the image incised (intaglio): all the printing parts must be *below* the surface of the plate. Colour is rubbed into the incised design then cleaned off the plate surface with a stiff cloth, such as scrim, and finally the ball of the hand. Damp paper is laid on the inked plate and pressure applied by means of a press. When the paper is lifted the ink has been transferred to it from the plate.

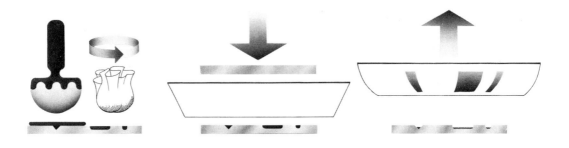

Intaglio printing plates are usually made from sheet metal; copper, zinc or mild steel are commonest. Copper is generally preferred because it is malleable or capable of re-working where corrections have to be made. Zinc and mild steel are considerably cheaper than copper and are widely used. Plastic sheet is also used and plates made by gluing flat objects onto backing sheets.

Two methods are used to incise the design into the plate surface: acid which etches the metal (see pages 62–63) or cutting the design into the metal with various tools (see pages 64–65). There are many formulae for the acid bath depending on the metal of the plate and the speed of etching required, but nitric and hydrochloric acids are the most common. The plate can be removed from the acid bath and part stopped (covered) with varnish to prevent further etching, so the plate can be bitten to varying depths. The deeper the design the more ink the intaglio will hold and the darker it will print.

Alterations are made by burnishing and re-working the area. The design has to be in reverse so that it reads the right way when printed. There are several different types of intaglio colour printing (see pages 66–67). Printing ink is oil-based and the paper must be sized so that it will not disintegrate during damping and printing. The intaglio press has to be well-built to give a very high pressure of five tons per square inch.

Characteristics of intaglio prints

In general intaglio prints rely on fine drawing and texture more than on colour. The most obviously recognizable characteristic is the impressed edge of the metal plate, and the slight embossment of all inked lines where the paper has been pushed into the intaglio by the very high pressure used to print it. Old intaglio prints have often been trimmed into the plate area so the plate mark has gone. The height of the embossing depends on whether the damp printed paper is dried under weight or by being stretched from the edges while drying. It also depends on the type of paper used: heavy paper holds the deformation more.

The quality of the line or texture reveals how the plate was made: the engraved line is crisp and controlled, the etched line is slightly irregular and freer as the drawing needle is offered no resistance by the wax ground (see page 62). Mezzotint shows a slight criss-cross texture in the mid-tones (see page 64) whereas aquatint shows an all-over irregular pattern (see page 63). Extremely fine lines, finer than a hard pencil drawing, can be printed both by engraving and etching but large areas of ink can only be held on the plate, prior to printing, by means of a texture either by aquatint, mezzotint or closely incised marks.

Terms associated with intaglio prints

Intaglio prints are also called copperplate prints and the words gravure and engraving are used indiscriminately for all forms of intaglio prints. The method of producing the intaglio gives its name to the subdivisions. Using acid: line or hard ground etching, soft ground etching, aquatint, lift-ground aquatint and photo-etching. Without acid: engraving, drypoint, mezzotint, collagraph (see page 65) and machine-tooled plates. Embossing is usually printed on an intaglio press from engraved wood, lino, metal or assembled blocks. The action of the tools used describes the quality of line and texture, hence needling in line etching, burnishing in mezzotint and aquatint or burin in engraving. Photogravure (see glossary) is the general term for commercial intaglio printing but recently artists have also been using it as an alternative term for photo-etching.

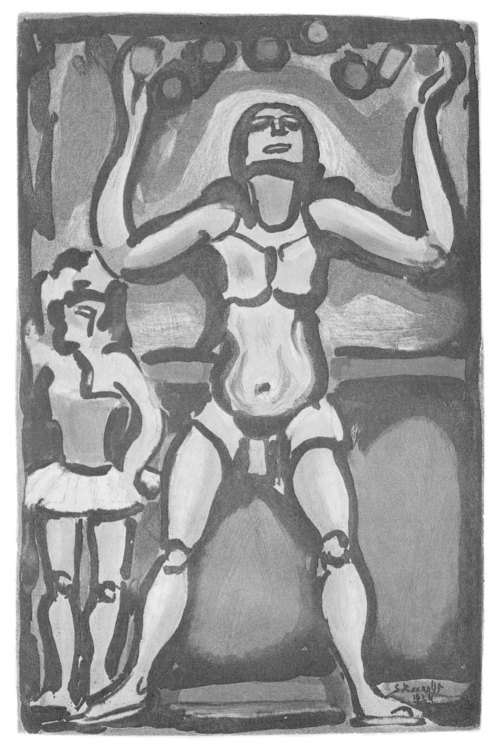

Cirque l'Etoile Filante, Georges Rouault, aquatint

50

Lithographic printing

The printing plate has the image on it and it is chemically part of the surface. The image is greasy and the non-image areas are water absorbent. Colour is rolled onto the plate and adheres only to the greasy image, being repelled by the damp areas: the plate is alternately sponged with water and rolled with ink. Paper is laid on the plate and pressure applied by means of a press. When the paper is lifted the ink has been transferred from the plate onto the paper.

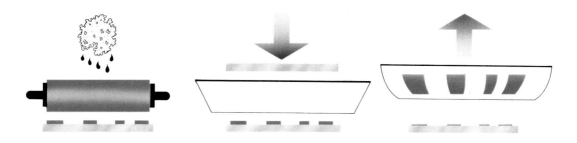

Lithographic plates are made from slabs of limestone or sheets of zinc or aluminium. The best limestone, close textured and pure, comes from Bavaria but the quarry is now closed and old stones are re-used. They are prepared by grinding off the previous image to leave a clean surface. Metal plates are given a grained surface texture to approximate that of the natural stone and are lighter and more flexible to use.

The printing image is drawn or painted on the plate with chalk or ink (tusche). The image can also be transferred from another surface to the plate (see page 69). This is then treated with chemicals which fix the grease content onto the surface layer of the plate.

Alterations can be made to stone, to a lesser degree to zinc and only with difficulty to aluminium. One plate is required for each colour printed and the design has to be in reverse for direct printing although not if transferred or offset printed (see below) as in the last two methods the direction of the image is reversed twice.

The printing ink is oil-based and lightly-sized papers are preferred. Two types of press are used: direct and offset. In direct lithography the paper is laid straight on the inked plate. In offset lithography the inked image is first picked up by a large rubber cylinder and is then transferred onto the paper. Presses used by artists rarely print paper more than thirty by forty inches.

Characteristics of lithographic prints

In general lithographs show brush marks and textures comparable with drawing and painting and use a wide range of colour. Printing inks are usually transparent and are applied in a thin layer so that when one colour is printed on top of a previous colour both are modified where they overlap. For example red on top of blue will make a purple. The whiteness of the paper reflects through the thin colours giving brilliant hues.

The quality of the line or texture reveals how the plate was made. Liquid litho drawing ink used with a brush produces the same fluid movement that it would on paper and if used with a pen looks like a pen and ink drawing. It can also be spattered, dripped or applied in any way that liquid ink is used on paper. Litho drawing ink also comes in the form of hard and soft crayons which give pencil or pastel-like lines. It can also be rubbed, shaded and smeared on the plate. Liquid litho ink can be diluted to give the effect of watercolour wash or when mixed with turpentine gives a marbling effect. There is rarely a plate mark as the paper is usually smaller than the plate.

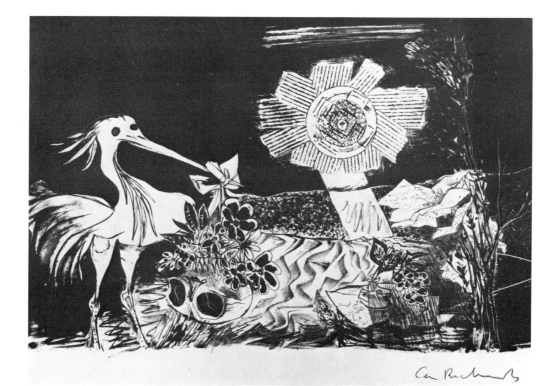

And Death Shall Have No Dominion, Ceri Richards, lithograph

52

Terms associated with lithographic prints

Lithographs are sometimes called lithos. The subdivisions describe the materials used, the method of making the plate or the method of printing: stone lithography, plate lithography (from metal plates), direct or offset lithography, transfer lithography, Diazo or continuous tone lithography (see page 69). The term autolithography was used to describe artist-drawn prints as opposed to those drawn on the plate by copyists, who are known by various names such as *chromiste* and chromo-lithographer. The textural effects are also used to describe lithographs; hence drawn and crayon lithographs, wash or tusche lithographs. A French word *lavis* is also used to describe wash effects. Photo-litho and offset are the general terms for commercial lithographic printing.

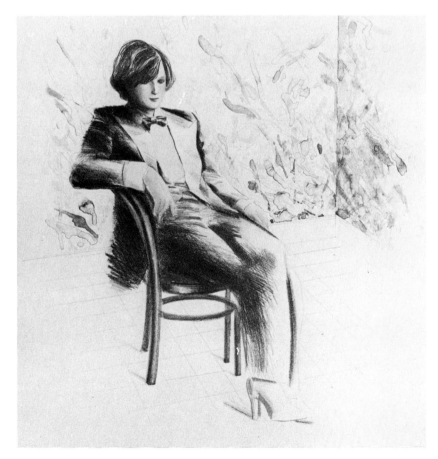

The Singer, Adrian George, lithograph

Screenprinting

The printing screen is a finely woven textile which supports a stencil, stretched on a frame. The open mesh of the fabric constitutes the image and the stencil seals the mesh in the non-printing areas. The paper is placed beneath the screen and colour is pushed from one end of the screen to the other by a squeegee. Ink comes through the open mesh parts of the screen and is deposited on the paper beneath.

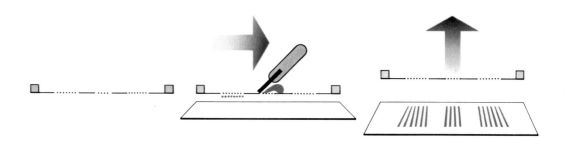

Screen textiles are woven from silk, nylon, polyester or cotton. The rectangular screen frame is made of wood or metal. Stencils are of three basic types: screen fillers, sheet stencils and photographic stencils. Screen fillers are in liquid, paste or crayon form such as glue, varnish or wax and are drawn, brushed or smoothed onto the screen. Sheet stencils, to seal large areas of the screen, are cut from paper, sheet shellac or plastic sheet and are stuck on the screen. Photographic stencils are either direct or indirect. The first requires a light-sensitive coating direct on the screen and exposure with a negative to light. The second uses a photographic negative which is stuck onto the screen. Alterations to drawn and cut stencils are easier than to photographic stencils. The design is not reversed on the screen and one screen is needed for each colour.

Printing inks are very versatile and can be water-based, oil-based or plastic-based and either opaque or transparent. Any type of paper, and almost any material, can be screenprinted. Fine detail requires a smooth-surfaced paper otherwise there are few restrictions.

Printing tables vary from the simplest screen hinged along one edge to a flat board using a hand-pulled squeegee to fully mechanized equipment. The squeegee is a flexible strip of rubber held in a wooden handle, as wide as the screen. No pressure is required in printing and the equipment can print very large prints.

54

Collage for Nettleton, Eduardo Paolozzi, collage for a screenprint, from a series of nine

Characteristics of screenprints

In general screenprints incorporate large areas of solid colour and often the images derive from photographic sources. Early screen inks were thick and a three-dimensional deposit of ink could be seen on the prints. Inks are now very thin, though where the effect is required, thick inks can still be used. Opaque inks can obliterate the colour beneath and metallic and fluorescent colours are superior when screenprinted. Screenprints have often been extremely large, no other printing method could compete for size, and artists seized the opportunity to work on a large scale.

The quality of the printed mark reveals how the screen stencil was made. Direct working on the screen with a brush and liquid screen filler gives a painterly effect or when wax crayon is used a coarse drawing effect. The texture of the woven mesh can be seen as an irregular edge in direct work. Cut stencils give a crisp edge but detailed work is limited by the inflexible cutting knife used. Photographic stencils also have crisp edges and can give very fine detail.

A characteristic of screenprints today is the use of many different elements which are assembled together: drawings, hand-written or typeset words, photographs of objects or people, in fact almost any visual material can be incorporated. A collage can serve as the starting point which is then photographed and made into a number of photo-stencils (see page 70). These can be modified by adding further work by hand, so they are often a combination of manual and mechanical techniques.

Terms associated with screenprints

Screenprints are also called serigraphs, silkscreen prints and sieve prints. The term serigraphy has been used by some artists to describe stencils made directly by them on the screen as opposed to cut and photo-stencils which are frequently made by technicians. Hand-stencilling using a brush or sponge dipped in paint and a stencil cut out of thin metal sheet is called *pochoir* and is sometimes used for artist's prints but more usually for facsimile copies of watercolours. Posterization is a technique developed to make a type of photo-stencil (see page 71).

The influence of photography

During the early years of photography in the mid-nineteenth century artists saw it less as an exciting additional tool than as a threat to their livelihood. Delacroix, Manet and many other artists made use of photography but when it was widely adopted by commercial printing to produce cheaper and quicker illustrations many artists dissociated themselves from it.

Post Second World War technical developments using photography in commercial printing coincided with a new movement in art which derived its images from the cinema, advertising and press photographs. Screenprinting offered the greatest flexibility for the incorporation of these photo-based images, though they also appeared in other prints. The major advantage of screenprinting was the lack of a historical tradition to inhibit artists and technicians who wanted to create a new kind of print and together they devised many new methods and effects. Photography is widely used today as a substitute for the artist's sketch book in the gathering of visual information which may be used in various ways, either as reference material which is re-interpreted in another medium, such as a painting, or by direct inclusion in a photo-etching, lithograph or screenprint.

Are photographs original prints?

Photographs are now offered for sale in signed limited editions by reputable galleries. The negative is equivalent to the printing matrix and many identical copies can be made – it is difficult to argue that they are not prints. I think, however, that they are a distinct enough group and need not be included in the category of artist's original prints. Photographers have long had their own exhibitions and the special qualities of photographs are clearly appreciated, in spite of the fact that today almost everyone takes photographs. Borderline cases in which photographs are stuck onto artist's prints or photographs on top of which artists have added work by hand or screenprinting blur precise definitions. To some extent it must remain a personal choice whether these and other borderline cases are acceptable or not as original prints since the loose usage of the word 'print' creates many ambiguities (see page 112).

Mixed media prints

It is quite common to find prints in which more than one printmaking method is used. This is usually done to exploit a special characteristic, such as the covering effect of opaque screenprinting ink or the extremely fine engraved line obtainable on a copper plate or to contrast the wash effects unique to lithography. The most common combinations are screenprinting on top of lithography, as in the Anthony Donaldson print below in which the water spray is printed in opaque white on an atmospheric litho drawing. Etched lines are often printed on top of litho and blind embossing, possible only with an etching press, is added to many prints. There can be a problem here as the paper is usually damped to get a good, deep embossment and paper which is already carrying several layers of ink may not damp well. Dry embossing with metallic powders is called foil blocking because originally very thin sheets of real gold foil were used (commonly seen on hardback book spines) but today

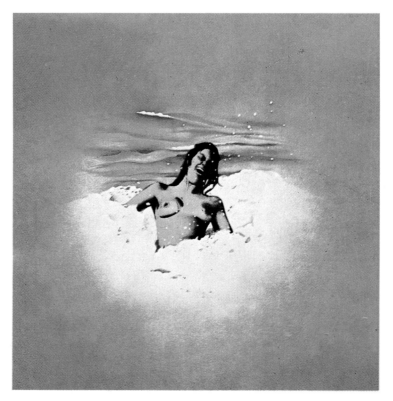

Christine, Anthony Donaldson, lithograph and screenprint

58

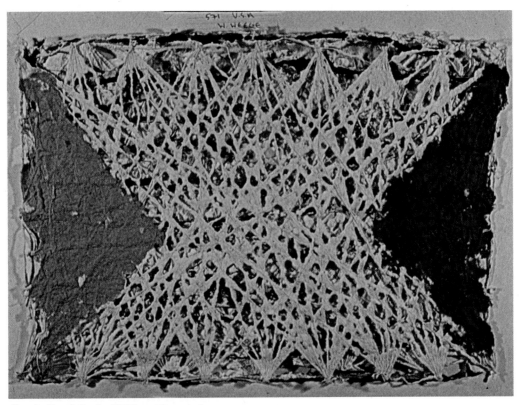

Gucci, Gucci Pooh, William Weege, formed paper print

aluminium and bronze powders, supported on a plastic film or foil, are used in imitation. Artists such as Hundertwasser in Germany have used foil blocking on top of screenprints.

Screenprinting is possible on almost all surfaces and it is used to print on assemblages or prints composed of a collage of paper, plastic and metal and other materials. Both Rauschenberg and Tilson have made use of the flexibility of screenprinting, Richard Smith used it to print on cast aluminium sculpture and it has been used to print on plastic sheet before vacuum moulding and also once the moulding has taken place. It is also used to print a varnish base on which flocking fibres are deposited and aligned by electric current to make a velvet-like pile.

Paper pulp in its raw state is also manipulated by artists who form it, introduce threads, leaves or other pieces of paper and colour it while it is still wet. The 'formed paper print' is allowed to dry and may then have other colours printed on top like the print above by Weege; Hockney and Rauschenberg have also made formed paper prints.

Variations on the basic printing methods

Characteristics of the most common techniques are described below but it must be emphasized that all artists devize their own particular methods and tools. Artists who cut or engrave, whether wood or metal, have favourite knives and gouges which, over years of sharpening, take on very curious shapes. Improvization plays a large part in experimental printmaking and variations on the traditional methods are not uncommon. Artists constantly invent new ways of solving problems as traditional materials become unobtainable and have to be replaced by modern alternatives.

Woodcut most woods can be used, with the exception of those which exude resins that inhibit ink. The grain runs parallel to the surface of the block. Very coarse grain woods permit only coarse cutting. The grain can be emphasized by wire-brushing the soft part of the wood grain away. Wood blocks can be of any thickness, limited only by the type of press used. If the print is burnished there is little restriction on size, especially if paper on a roll is used. The design is outlined on the wood block by cutting with a knife and the non-printing areas are cut away to a depth of at least $^1/_8$ in. taking care not to undercut and weaken fine detail.

White Horse Sunrise (detail) by Michael Rothenstein exploits smooth and weathered wood grain

Wood engraving fine woods with the grain running at right angles to the block surface are used for wood engravings. The end grain (or cross grain) gives little resistance to a sharp tool so very fine lines can be engraved with a graver, wider lines with a spitsticker or scorper. Box wood is generally used, but as it does not grow to any great size larger blocks are made up of several sections joined together. Blocks are usually made to the same thickness as type so both can be printed together, if required. The blocks rarely exceed twelve inches long and are generally much smaller and are used for book illustrations, book plates and devices such as crests.

Trees (detail) by Diana Bloomfield shows the fine detail which is typical of wood engraving

Linocut thick, plain linoleum is preferred and it is cut in the same way as a woodcut, although the tools do not need to be so robust. The texture of the powdered cork and linseed oil which makes up the surface of lino permits only rather coarse working, fine detail tends to crumble during printing. A solution of caustic soda can be used, with care, to etch the surface into a granular texture. Lino prints large flat areas of colour well and is often used in combination with wood blocks which provide a surface for detail. The quality of the cut is noticably free in comparison to that in wood.

Tessa (detail) by Peter Daglish shows typically bold cutting

Card or cardboard prints strong, smooth card can be cut into jig-saw shapes. It takes oil-based inks very well and will last long enough to print an edition of one hundred without difficulty. The card is cut with a knife and designs are restricted to fairly simple shapes. If the jig-saw pieces are inked in various colours and then reassembled a multi-coloured print can be taken at one impression: a thin white line will show between each colour. Alternatively each section could be printed separately, tightly abutting to the other colours, or allowing a small overlap, so there is no gap between colours. Such designs rely on colour contrasts for effect.

Mlle. (detail) by Anne-Marie Le Quesne uses large, flat areas of colour for dramatic effect

Other relief blocks anything which can be inked and is not too uneven can be printed by the relief method. Objects such as leaves, string, match-sticks, coins, lace, metal pressings – the list is endless – can all be used. Usually they are glued on to a piece of card to keep them in position and the surface sealed with several coats of PVA varnish. Type metal units such as stars and dashes are used as is type itself. Other materials frequently used include chipboard, cork, wire mesh, plastic sheet, metal sheet, formed fibre-glass, basketry and many fabrics. They are used in combination with wood and lino but the more fragile surfaces restrict the number of prints.

Experimental Study (detail) by an anonymous student shows the use of different surfaces

Japanese wood block prints contemporary Japanese artists have revived the traditional methods using water-based colours. Plywood has largely replaced woods such as cherry, maple and sycamore which were previously used. Wood cutting techniques are similar to Western methods though the tools are held in the hand rather differently. Colour is applied to the block by brush, hand-made paper is used and the impression is taken by burnishing with a baren (see glossary). Rich colour blends and vibrant colours are typical of this technique which is often combined with screenprinting, lithography and embossing.
Camouflage World 9 (detail) by Akira Kurosaki is characteristic of this method of printmaking

Line or hard ground etching zinc, copper or mild steel sheet is covered with a thin layer of wax. The design is drawn through the coating with a needle which exposes the metal beneath. The sides and back of the plate are protected with varnish and the plate is immersed in acid. The acid bites the exposed metal to varying depths, depending on the strength of the acid and the length of time in the acid. Parts of the design can be protected from further biting by more varnish – known as stopping out. After etching the plate is cleaned and ready for printing. The wax coating offers little resistance to the needle so lines can be very freely drawn.
Crossroads (detail) by Francis Kelly shows the fine lines typical of hard ground etching

Soft ground etching zinc, copper or mild steel sheet is covered with a thin layer of wax which is much softer in consistency than a hard ground wax (described above). A sheet of paper is placed on the top of the coated plate and the design is drawn on the paper using a pencil. When the paper is removed it pulls off the wax where the lines have been drawn leaving a chalky texture on the exposed metal which is then etched. Leaves and fabrics can also be impressed into the soft wax, leaving a pattern of exposed metal which is then etched. A soft, irregular line and texture results from using a soft ground giving an informal, sketch-like quality.
Two Eggs (detail) by Terence Millington uses a fabric texture on the background of the print

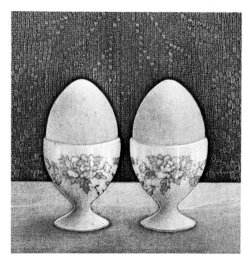

62

Aquatint powdered resin is dusted onto a metal plate and when it is gently heated melts sufficiently to adhere in globules. The resin can be finely or coarsely powdered and dusted lightly or thickly so that a wide range of deposits are possible. The resin particles act as an acid resist so that when the plate is put in the acid bath biting occurs round each particle giving an irregular texture. There is additional control by the strength of the acid and the etching time. A very wide range of tones is obtained by the aquatint texture holding variable amounts of ink. It is often used in conjunction with line etching and other intaglio methods.

Winter Flowers (detail) by Donald Wilkinson uses pure aquatint to give a soft effect

Lift-ground or sugar-lift aquatint the design is painted directly on a clean metal plate using a mixture of sugar and indian ink. When dry the whole plate is covered by a coat of varnish. When that is dry the plate is immersed in water which penetrates into the sugar solution and lifts it off leaving the metal exposed where the drawing had been. This is given an aquatint texture and etched. The artist works in a positive way, drawing what will print rather than stopping out what will not, which promotes a free style of working with a painterly quality. In addition the variable tones of aquatint can also be used to enrich the design.

Darkling Thrush (detail) by Norman Stevens has a sketch-like immediacy using a lift ground

Photo-etching a metal plate, usually copper, is coated with a light-sensitive emulsion. This is then put in contact with a photographic negative and exposed to light, which hardens the clear parts of the design. When processed the hardened parts of the coating act as an acid resist and the plate can be etched. If the design is composed of any areas broader than a line an aquatint texture is required to hold the ink in these open parts otherwise it would be removed during cleaning of the plate prior to printing. High-contrast or screened negatives (see glossary: mechanical screen) are usually used though drawn negatives are equally effective.

Bowman's Shop Front (detail) by Alyson Stoneman is based on her own photograph of the shop

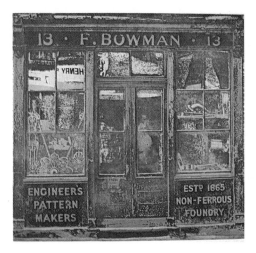

63

Engraving copper is the best metal for engraving. The design is cut directly into the metal by a steel graver or burin which has a lozenge shaped tip and is kept extremely sharp. Only two types of mark are possible: a line and a dot. These can be of varying width and depth to hold more or less volume of ink and therefore print lighter or darker. The burin cut produces a spiral or point of metal which is cut off by a sharp scraper leaving a clean-sided mark. The burin is held steady and the plate turned when a change of direction in the line is required. Engraving appears very precise and it requires great skill in controlling the burin.

M. Bernédé's Vineyard (detail) by Anthony Gross shows the typical swelling and turning line

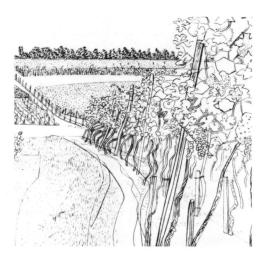

Drypoint a hardened metal point or diamond tipped needle is used to scratch the design into a metal plate. Ink is held in the scratch mark and also in the burr of metal on each side of the scratch giving a notably fuzzy edge to the line. The burr wears down quickly unless the plate is steel-faced to enable more than an average of 15–25 prints to be taken. Drypoint is often used in combination with etching to give emphasis to parts of the design. Drypoint marks can also be made with a spiked roulette or even sandpaper pressed into the metal surface. The characteristic line is subtle and use made of the burr.

Vilma Banky (detail) by Frank Martin shows how the velvety burr marks can be used to express form

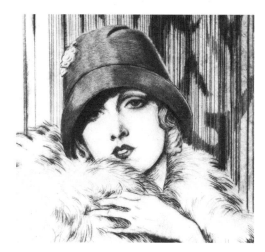

Mezzotint a metal plate is indented all over with tiny pits by means of a toothed steel rocker which is worked in all directions until the plate is covered with a regular texture. Each pit will hold ink and should the plate be inked at this stage it would print almost solid black. To make the design the artist rubs down some of the pits with a burnisher to diminish the amount of ink held. Where highlights are required the plate is burnished and polished quite smooth. A very wide range of tones are possible in mezzotint and it is noted for its velvety blacks and the fact that the design is usually light on a black background.

For an Uncertain Departure (detail) by Mark Balakjian shows the subtle tones of mezzotint

Machine tools mechanized tools and cutting devices are all used by artists to incise intaglio plates. Drills are used to make regular holes and electric engraving tools, including dentist's drills with various heads, are used to incise more flexible lines and marks. Grinding and polishing discs can be used to roughen or make smooth parts of a plate. Some artists have made use of oxyacetylene and other gas cutting torches to burn the design into the plate. All these tools leave their characteristic marks on the plate and affect the way the marks hold the ink. They are often used in combination with conventional etching.

The Way (detail) by Alena Kucerova is made using a gas powered cutting tool

Collagraph (collograph): collage plates intaglio printing plates can be built up rather than incised. Shapes cut out of metal, tough card and plastic sheet can all be assembled on a backing plate and glued to keep the pieces in position. Found objects such as metal pressings and natural materials can also be incorporated. These plates are inked like an intaglio plate or in combination with surface inking (see page 66) utilizing the different levels which have been built up. The collage is usually protected by a layer of varnish over the surface, particularly when fragile materials are used and this gives characteristic soft contours when printed.

Branded (detail) by Cynthia M. Knapton is printed from a collage of leather

Embossing a design that makes use of embossing which is deeper than an ordinary etched line. The design must be bitten to the depth required or even right through the plate. Surface colour can be rolled on the top of the plate or the embossing can be left to stand on its own as blind or inkless embossing. An intaglio press is generally used as it gives the greatest pressure of any of the presses. Engraved wood and lino also emboss well on an intaglio press. The paper must be of good quality, thick and well sized, to withstand and keep the deformation of its surface. Extra-soft blankets are used to push the paper into the design.

Tofukuji Falling Water (detail) by Birgit Skiold relies on the play of light and the paper texture

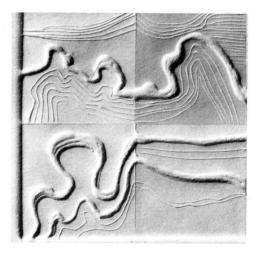

Intaglio and surface colour printing

The method developed by S.W. Hayter in his Atelier 17 in Paris utilizes the fact that inks of different viscosities do not mix. The intaglio plate is prepared with several distinct levels. A typical method would start with a thick ink being pushed into the lower levels, a thin ink is then rolled onto the surface with a hard roller and then a third colour of medium thickness can be rolled on top of the other two colours. The plate has to go through the press only once to print all three colours. Inking the plate can be a lengthy process and it is usual to see very slight variations in colour between prints in the edition.

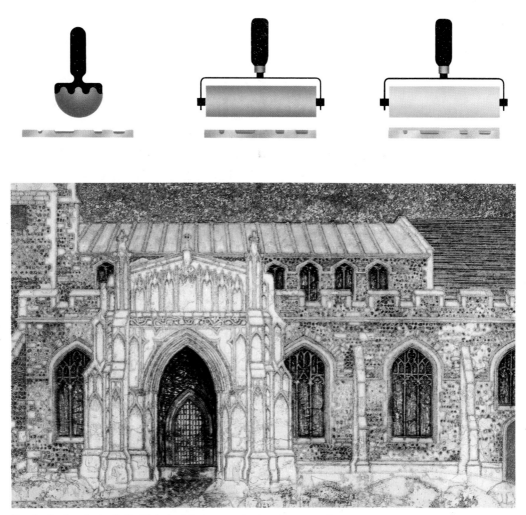

Boxford Church, Suffolk, Valerie Thornton, single plate aquatint

Other forms of intaglio colour printing

Multi-colour inking of plates in patches is another way of using a single plate. The dabs of colour are applied to the plate by means of a dolly or *poupée* (a stub of felt or twist of cotton with padding inside) or brushes and fingertips. Masks and stencils can be used to protect and reveal parts of the plate and keep colours in place. The cleaning of the plate surface has to be done carefully so that the various colours do not mix and this is a slow process.

Jigsaw plates use one plate cut up into sections which are individually inked in different colours and reassembled to print together. The different colours are separated by a thin white line the thickness of the saw blade.

Many colour intaglio prints are made from several plates, either using one plate per colour or several colours to two or more plates. Multi-plate prints often make use of complementary colours, perhaps one warm colour and one cool colour which, when printed on top of each other, harmonize. The primaries, red, yellow and blue, are used in three-colour prints and when overprinted, result in quite a wide range of secondary colours. Black may be added as a fourth plate to this system (see glossary: four-colour half-tone), which is based on magenta red, cyan blue, spectrum yellow and black. These are the standard pigments used in commercial colour reproduction but artists frequently modify one or more of them. By changing the magenta to an orangy-red, for example, the balance between all the colours is altered.

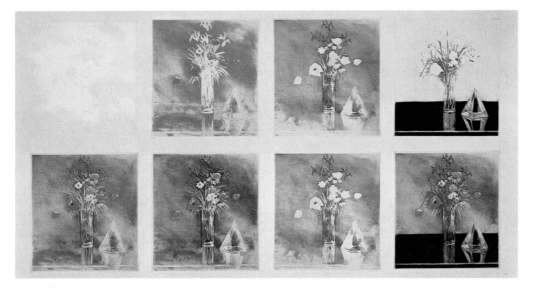

Still Life (colour exercise), Terry Willson, four plate aquatint

Drawn litho the artist treats the smooth stone or grained zinc plate very like a sheet of paper but uses litho crayon or chalk as the medium of drawing. Litho chalk is made from a mixture of wax, soap and lamp black and formed into small sticks and crayons. These are made to various degrees of hardness giving finer or thicker lines. In block form the chalk can be rubbed to give broad tones. Chinagraph and lead pencils as well as ball point pens all contain enough grease to make an image on a litho plate. The litho crayon is black (to show up on the stone or zinc) but after processing the plate can be printed with any coloured ink.
Goshawk (detail) by Don Corderey, six plates were used to build up this detailed image

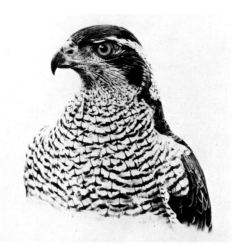

Tusche or wash litho a liquid, greasy drawing ink is used on stone or plate and applied with a brush or pen. In a diluted form it gives a watercolour-like wash. On stone it dries by absorption and evaporation giving soft edges; on plates it dries by evaporation only, giving much harder edges to the wash areas. When the ink is mixed with gum and turpentine the wash gives a globular effect. Ink can also be spattered by brush or dabbed on with textured fabrics. The effects using litho wash range from the palest tone to the most dense and can be printed in any coloured ink. Wash is generally used with drawn litho to emphasize parts of the image.
Eagle Owl (detail) by Elisabeth Frink. Very dilute ink conveys the movement of the bird

Photo-litho grained zinc and aluminium plates can be coated with a light-sensitive emulsion. If placed in contact with a photographic or hand-drawn negative and exposed to light the exposed areas of the negative let through light which hardens part of the coating. After processing the hardened coating acts as a grease-attractive image just like a drawn litho image. Photo-litho is used for images which are derived from photographic sources which may be created from high-contrast negatives or may use the half-tone system (see page 71). As aluminium plates have a shallow grain they are best printed on presses with a mechanized inking system.
Derbyshire Farm (detail) by David Mindline, an experimental high-contrast photo-lithograph

68

Transfer litho from paper cartridge paper can be treated so that a drawing using litho chalk or tusche can be transferred from it onto a plate. The advantage being that the artist need not carry a heavy litho stone or unweildy zinc plate if he wishes to work outside the printing studio. Transfer paper can be easily sent by post and as the drawn image is put face to the plate for transferring the image is reversed and so is drawn on the paper reading the same way as it will when printed. There is a slight loss in the quality of the image during transferring but the plate can be worked on further to strengthen any light drawing which looks weak.

Man in a Top Hat (detail) by Albert Houthusen is a bold drawing which has transferred well

Transfer litho from objects objects which have a natural grease content will leave an image on the litho plate. There is enough grease in the skin for fingerprints to register. Other objects can be covered in a greasy substance or litho ink and can be impressed directly on the plate or first printed onto paper and that, in turn, impressed on the plate. Pulls from intaglio or relief blocks can be transferred as can fresh pulls from type matter. Textures transferred from leaves, fabrics, wood grains, carvings, rubbings of all sorts can be used. Such transfers are usually only part of a design and are complemented by crayon and tusche work.

Green Metaphor (detail) by Ceri Richards uses a transfer from a large leaf for this poetic image

Transfer litho from film (Diazo or continuous tone litho) the artist draws with an opaque substance, such as black ink, paint or crayon, on a sheet of transparent plastic: this is a positive (as opposed to a negative). An aluminium plate is coated with a 'positive-working' light-sensitive emulsion and placed in contact with the positive, after exposure to light the plate is processed in the same way as a photo-litho plate. The special formulation of the emulsion, working with the combined subtle grain on both the plate and the plastic sheet used for the positive, produces a fine gradation of tones akin to the continuous tones seen in a photograph.

Ideas for Sculpture 1975 (detail) by Henry Moore shows the typical texture obtainable

Drawn stencils the artist works directly on the stretched fabric of the screen using substances which will fill in the holes between the fibres. There are two basic approaches: positive working by filling all the non-printing areas or negative working by drawing the printing areas in a soluble substance, covering the entire screen with an insoluble substance and dissolving out the drawn areas which constitute the printing image. Wax crayon, litho tusche, varnish, glue, shellac dissolved in methylated spirit and many proprietary screen fillers are used. Such screen prints make much use of painterly brush-strokes and free drawing.

Afternoon (detail) by Michael Carlo has all the freshness of direct working on the screen

Cut stencils many materials in sheet form which are impervious to printing inks can be used to seal areas of the mesh. The simplest is thin paper, cut or torn into shapes, which are placed on the underside of the screen and are held in position by the suction of the squeegee passing back and forth. Other specially made sheets, traditionally sheet shellac, but now usually plastic sheet on a backing paper, are cut with a knife and stuck onto the underside of the screen either by heat or an adhesive. Cellulose tape is used for straight-edged parts, either stuck on the underside of the screen or as a mask for painted straight lines.

Plakias (detail) by Anthony Benjamin shows the characteristic hard edges of cut stencils

Photo-stencils direct photo-stencils are made by coating the mesh itself with a light-sensitive emulsion, placing it in contact with a negative, exposing it to light and washing away the soft part of the emulsion, which constitutes the printing part of the design. Indirect stencils are made with the light-sensitive emulsion carried on a supporting film. After processing the hardened parts of emulsion can be stuck on the mesh of the screen and the supporting film peeled away. High-contrast or screened negatives using the half-tone system are used where the image derives from a photograph. Often combined with drawn and cut stencils.

Artificial Light (detail) by Steve Walton is based on a colour photograph

70

Half-tone and posterization

Continuous tone in a black and white photograph is due to the variable darkening of the silver salts in the emulsion. To translate this into relief, intaglio, litho or screenprinting, all of which are binary systems ie. ink or non-ink areas, an optical illusion is utilized. The half-tone system is used for most commercially printed illustrations and reproductions. The photographic negative is put in contact with a screen of fine criss-cross lines: light tones come out as fine dots and dark tones as larger dots; they are all very small and blend optically so that tone seems to be continuous as in a photograph. The dotted image is used to make photo-blocks, photo-plates and photo-screens.

An alternative method is posterization which is widely used in screen prints. The gradation of tone in a photograph is analysed by several varied

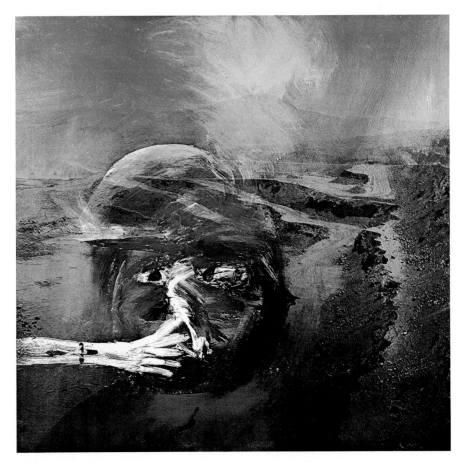

Miner Smoking Sidney Nolan, screenprint using posterization

time exposures in a camera into a series of distinct tones: light, mid and dark. Each is made into a separate screen and printed in sequence light tone first. The effect is a series of halos which give the impression of continuous gradation of tone. Both systems are used for monochrome and coloured prints.

Reduction prints

By this method a print in several colours is taken from only one block, plate or screen. Progressively more of the printing surface is modified: cut away on a relief block, added or rubbed down on an intaglio plate, added to a litho plate and added to or dissolved from a screen. They are also sometimes known as 'suicide' prints because all the sheets of paper have to be printed with the first colour before the matrix is modified for the second colour and so on.

Registration of colours

Colours printed on top of each other must be in exact correspondence or registration. A variety of systems are used depending on the sophistication of the printing method and press used. Relief printers fix side and corner paper guides onto the block itself (see Kento in the glossary) or on the press and mark the exact position of the block on the press bed. Intaglio printers, if printing the colours immediately one after another so the paper does not dry between printings, keep one end of the paper nipped inbetween the roller and the press bed, while exchanging the plates in a set position. In direct lithography a needle at either end of the sheet of paper sticks through to locate a small hole on the plate surface beneath. Offset machines have mechanical grippers to hold the paper in constant relationship to the plate. Screen printers fix the screen and table base by hinges and mark the paper position beneath the screen.

Proofs are sometimes seen with two crosses, or a cross within a circle, at each end of the sheet. These marks are used when the registration system is mechanized or the matrix is made photographically. When a satisfactory pull is obtained, on which the registration is accurate, the marks can be erased.

The sequence of events in printmaking

Idea and matrix

A print necessarily starts out as an idea in the head of the artist which somehow has to be translated into the matrix or printing image. The transformation that the idea undergoes is conditioned by the operation of each printing method, since they differ considerably, particularly in the amount of changes that can be made. For example a cut made in a wood block cannot be undone, whereas a copper plate can withstand considerable re-working before the metal becomes weakened. The cost of materials used is also a factor: a mistake in a lino block, unless hours of very intricate cutting have already been done, might result in the artist starting a new block. All photographic materials for making plates or screens are now expensive so the artist puts more time into the preliminary preparation of the positive or negative rather than into the actual making of the plate or screen itself.

Some artists prefer to work out a design fully as a guide to preparing the matrix. This is helpful in lithography where the result of over-printing one colour on another creates a third, which can be very difficult to visualize when drawing a plate in black litho ink which may, for example, ultimately be printed in yellow.

Intaglio printmakers frequently start work on a plate without prior visual preparation of their idea. A proof is taken at an early stage and further work is then done after seeing what the incised mark looks like in terms of ink on paper. This is where experience counts: a certain depth of engraved line will print in a certain way; a wash on a litho stone looks stronger than it will eventually print; a burnished area on a mezzotint plate may look shiny and smooth but there is still enough texture to hold a little ink and give a grey look overall.

The general trend is towards a conscious adoption of printmaking for its special qualities as a medium of expression. The actual working of the matrix in terms of metal, stone, wood, or whatever other materials are used, is a very important element in the act of creating a print. There is far more involvement with the materials than in painting, in the polishing, cutting and effort. Sculpture which, incidentally, often has need of assistance from casters or other technicians has more in common with printmaking. For many artists the very intransigence of the materials and the physical effort required are all part of the attraction of printmaking and its processes.

Proofing

Even with great experience it is not always possible to judge the effect of ink on paper when the matrix is made. It is at this stage that all the alternatives can be tried. A broken black, a black with some blue or another colour mixed into it, may give a markedly better result than a pure black. A change of paper can bring out richness of detail only partially revealed on another paper. The order of printing colours is vital: yellow printed on top of black gives a green: if printed underneath the yellow is obliterated by the black.

The first colour to be proofed is usually chosen because it contains the most work and must act as a guide for the other colours. A proof can be taken in black and transferred to the unworked surface of another block or plate so that the work can be accurately positioned to register with the first block or plate. This is called a set-off proof and is helpful if very close or detailed registration is required.

During the proofing the exact mixture of colours used to make the printing ink is experimented with and recorded. The proportion of colourless base to pigment in transparent colours, for example, makes the mixing of the much larger quantities of ink required for the printing of the edition later more accurate. The amount of damping a particular paper receives or the pressure used on a press all affect the printing and are explored during the proofing period. Experimental techniques can only be assessed by proofing.

Alterations, corrections and re-proofing

A proof may sometimes be a failure: the artist's mental picture of the print may not have been translated into the printing matrices and considerable alterations and corrections may be required. These will depend on the materials and techiques used. Further cutting or engraving of relief and intaglio blocks or plates is easy. However it is more difficult to reinstate a worked area. It is possible to fill cut areas with plastic wood or plastic metal but this is not usually very successful. Photo-plates or screens cannot easily be altered and a new plate or screen is usually made after modifying the negative or positive. One of the reasons for the popularity of the intaglio methods is the relative ease with which adjustments can be made by polishing and re-working.

Changes and corrections are usually re-proofed to check the result. These proofs are known as states and can be of great interest as they show the development of an image through an amount of trial and error. Comparisons of states might also reveal the simplification of an idea or the elimination of a

colour which distils and strengthens the image. These pulls are also called working proofs, trial proofs or stage proofs and are collected in their own right.

Editioning and cancelling

Once a definitive proof has been obtained it is marked 'passed for press', 'ready for printing', or *bon à tirer* (BAT) indicating the approval of the artist, and this proof is the guide for the printing of the edition.

Slight variations in manual printing are inevitable and are a welcome sign of the individuality of each print. Mechanized printing tends to be extremely accurate but insisting on absolute exactitude in all the prints in an edition seems, to me, contrary to the spirit of printmaking. On the other hand wide variations are not to be encouraged either as they must reduce the intention expressed by the definitive proof.

If the printing of an edition is done in a professional workshop the whole edition is printed at once. Artists who print their own editions may print only part of the total number of copies to start with. The reasons include boredom with printing the same image over and over again, the time required to print a whole edition or even the cost of buying a large quantity of expensive paper. Artists should keep accurate records of part editions and maintain the quality throughout. At some stages of an artist's career they may need more different images to show rather than many copies of fewer images.

When the printing of the edition has been completed it is usual to cancel the printing matrix so that no further copies can ever be printed from it. Cancelling is done by defacing the surface of the plate or block in some way. A line or cross may be scored across the metal or wood, chemicals may be used to erase part of the image on a litho plate or screen or a hole drilled in the corner of an intaglio plate. A proof may be taken to show the effect of the cancellation and to demonstrate that it has, indeed, been carried out, though this is unfortunately by no means a universal practice. A young artist may think it unnecessary but regret it later when better known.

Checking, numbering and signing

After the printing is complete each print is scrutinized for defects. These may be faults in the paper not previously noticeable, part of an image not printing correctly, bad registration of colours, incorrect positioning on the sheet of paper or just a dirty thumb mark in the margin. These will all be rejected.

Each print in the edition is then numbered by the artist. This is usually done in pencil and placed in the bottom left-hand margin below the image. Numbering is usually done in the form of a fraction: 20/75 indicates print number 20 from an edition of 75. The number may not indicate the order of printing. In a multi-coloured print the last sheet of the first colour is on the top of the pile and becomes the first print to receive the second colour and so on. Since very large editions can be printed by lithography and screenprinting without loss of quality the first or last will not show any signs of wear or loss of detail. The number may be more relevant in an intaglio print using drypoint or very fine line etching which wears rather more quickly but steel-facing is now so common that this is no longer as important as it was in the days before steel-facing was invented (see glossary).

After numbering the artist then signs each print to indicate his approval with the result. The signature is usually put in the bottom right-hand margin beneath the image to balance the number in the edition. If the image extends to the edge of the paper another position has to be chosen either within the image (see page 35) or on the back of it. Pencil is traditonally used (rather than ink because it is difficult to tell if ink has been printed or hand written) and it cannot be erased or changed without disturbing the surface fibres of the paper. If the artist's signature has been incorporated in the matrix and is printed, it is known as signing in the plate, and means that the artist has not approved each print individually.

The edition

The total number of prints intended for sale or for distribution in some other way, such as a commemorative print which is given to a selected group of people, comprises the numbered edition. Occasionally second editions have been taken of very popular prints. This is considered reprehensible today and such a print should have 'second edition' clearly written beside the number.

The size of the edition will influence its value and generally editions over 150 copies are considered large, though not on the Continent where they are

more common than in Britain and the USA. With modern printing techniques most editions are artificially restricted as many more copies could be printed without loss of quality.

Artist's and other proofs

Over and above the edition copies there are a number of other pulls of which the artist's proof is most frequently seen for sale. Artist's proofs are intended for the records or archives of the artist, are identical to the edition prints and are printed at the same time. In place of the edition number 'artist's proof', 'AP', 'épreuve d'artiste' or 'EA' is written; some artists also number their proofs. The convention is that these proofs should not exceed a total of ten per cent above the edition quantity. Sometimes working proofs are also designated artist's proofs; there is no real standardization of practice among artists (for the misuse of the term artist's proof see page 114).

If the edition has been printed in a professional workshop it is usual for them to be given one signed proof for their archives. Where several printers, editors, publishers and distributors are involved in the project, which is not uncommon if artists in different countries are contributors to a suite, they may also be given a proof each which are designated *hors commerce* or HC (outside the prints in the edition which are for sale).

Some artists make an extra print for a member of their family, a friend or a special collection, such as that at the Tate Gallery in London; these prints usually bear a dedication in the hand of the artist. They are sometimes seen for sale and are collected for their uniqueness.

The role of the publisher and printer

Both publishers and printers have played an important part in the development of modern prints. They have worked in partnership with artists and together shared and solved many problems.

Ambroise Vollard is a particularly important figure as between 1900 and his death in 1939 he encouraged many artists to make prints. Most of his publications were elegant and sumptuous illustrated books. The first book was *Parallèlement* by Verlaine with lithographs by Bonnard, published in 1900. Vollard also commissioned Picasso, Chagall, Rouault, Derain and many others to produce remarkable books. Other important publishers were Maeght and Kahnweiler in Paris, Skira in Switzerland and, between the wars, many others in most of the cultural centres of Europe. These publishers acted as a catalyst, matching artists with printers and often financing the whole process.

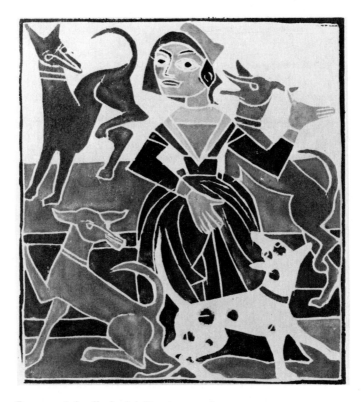

Pantagruel detail, André Derain, woodcut

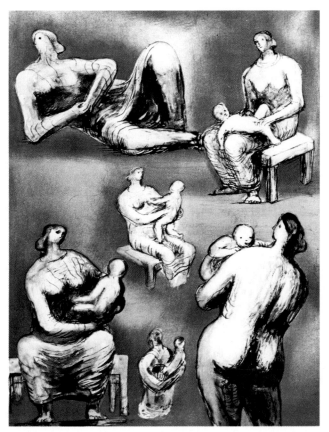

Reclining Figure and Mother and Child Studies, Henry Moore, lithograph

More recently a number of distinguished publishers have acted with rather tangled motives: hopes of profit and glory combined with a genuine love of art and a desire to make the work available. They have seen the potential of artists and given them a chance to try out their ideas, something which might not have been possible without such active support.

Tatyana Grosman's Universal Limited Art Editions on the East Coast of America and Ken Tyler's Gemini Graphic Editions Limited on the West Coast have been primary influences of this sort. In Britain there has been equally important support from publishers like Editions Alecto, Christie's Contemporary Art, Petersberg Press, Curwen Prints, Bernard Jacobson and galleries such as Waddington and Marlborough Fine Art. A recent change has been the involvement of some important printers who have also become publishers: Chris Prater, of the Kelpra Studio and Ken Tyler both started off as printers. The relationship between the artist and the printer is the making or breaking of a good print. If their temperaments are compatible the printer

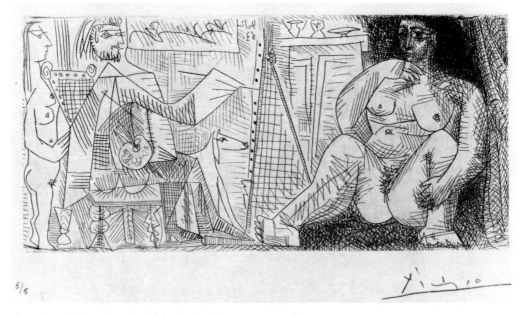

From *The Artist and his Model* suite, Pablo Picasso, etching

will anticipate what the artist wants to do, suggest ways of doing it, invent, if necessary, ways hitherto untried and generally contribute an enormous amount to the end product. In these circumstances the work could not have been conceivable without the printer and they are, in effect, the result of intense and close collaboration. Few artists can keep up with the technological developments and only specialist printers know the full range of inks, papers and finishes.

An example of happy collaboration is the series of etchings *The Artist and his Model* which Picasso produced during seven months, from March to October 1968. The brothers Aldo and Pierre Crommelynk set up a press near Picasso's villa in the South of France. They kept him constantly supplied with prepared plates and while he was drawing they were biting and proofing the plates drawn the day before. Three hundred and forty seven intaglio prints of great inventiveness were the result.

Another fruitful alliance is that between Henry Moore and Stanley Jones of the Curwen Studio in London. Jones makes a point of producing a wide range of colour variations while proofing Moore's lithographs. He also proofs one image on top of another or turns one upside down. These experiments delight Moore and are frequently chosen for editioning. Such creative master printers are often underrated but, of course, the ideas come from the artist originally and the printers are in a sense only an extension of the artist's intention.

80

The London Print Gallery of Christie's Contemporary Art

Where to find prints

Galleries and dealers

Some galleries and dealers specialize in artist's prints and tend to keep a large stock giving a wide choice. They may confine their stock to a group of artists or to prints designed for specific environments. Several galleries keep prints in addition to other works and limit these to their own particular artists. Some offer special selection services to corporate customers and interior designers. Generally speaking an artist who has made a reputation internationally as a painter or sculptor will be allied to one of the larger galleries who will also control any prints he does and probably publish them. During the late 1960s well-known artists were frequently under very strict contract to galleries, however this has since been relaxed somewhat so that many artist's prints can be seen in more than one gallery and it may be worth shopping around if a specific print is required. The majority of artists have never been under contract and act as their own publishers, so their work is not restricted in any way. Most print galleries have work displayed in bins or display wings and encourage the public to look round without fear of being pressurized into buying.

Shops and stores

A gallery within a store is now very common, particularly in America and Japan. These may be run by the store or, more usually, are a branch of a gallery elsewhere. Stores, by their very nature, cater for a wide cross-section of the public so the prints they tend to show are of general appeal. The buyer is unlikely to see the latest avant-garde ideas but will usually be offered a wide choice. It is often true, unfortunately, that the staff in such stores are not very knowledgeable about the prints, whereas specialist print galleries will offer sound advice.

Prints were traditionally sold in bookshops and often shared the same publishers. This relationship is still frequently seen though it is usually old prints that are sold rather than contemporary ones, partly because old prints are all too often torn out of books and framed as individual pieces.

Prints are often sold in craft shops today. Prints have long suffered under the stigma of being classed as applied art rather than fine art but now that their

position in the artistic hierarchy has changed and is no longer in doubt, their close association with the craft world can be acknowledged without disparaging either. It is regrettable that creative works are still divided into arts and crafts but the divisions are becoming increasingly flexible.

Museums and libraries

The would-be print collector will find museums are particularly valuable, they often house an important collection of historical prints which can be studied to advantage and they may also have a technical display of printmaking methods showing the tools and plates. They may have a specialist library, useful for reference and some museum shops are now selling artists' prints as well as the ubiquitous reproductions.

Some libraries house important collections of prints, such as the New York Public Library and the Bibliothèque Nationale in Paris. These are internationally famous but municipal libraries sometimes collect prints which can be loaned to public buildings and to individuals. They are also a source of reference books on the subject of prints and printmaking. It is worth finding out which libraries specialize in art subjects as this will save considerable time and effort.

Art centres and art schools

Prints are frequently seen under the umbrella of an art centre – in the form of a special exhibition or a print loan scheme for their members. Printmaking studios may be housed in the same complex and classes held on print appreciation and practical studies. Art schools and colleges are the principal source of teaching for all forms of printmaking and their diploma shows and open exhibitions are well worth visiting. Prints by students may not be a long term investment, though some become valuable, but such prints are inexpensive and you have the satisfaction of giving encouragement when it is most needed.

Artists' studios

Formal open days at an artist's studio are often part of a local event and it is always interesting to go and see what equipment is used and the working surroundings, sketches and work in progress all add to one's understanding of the subject. Professional printmaking studios also occasionally open their doors to the public and it is worth finding out if they have any such event planned.

Title Page for *Stones and Bones*, John Piper, screenprint

Print auction at Christie's, London

Buying and selling prints

Direct buying

Since prints exist in multiples, print galleries often quote two prices: framed and unframed. They may have just one copy and insist that, if framed, it is only available with that frame, though most will appreciate that the choice of framing is a personal matter. If it is unframed and the buyer does not wish to ask the gallery to arrange framing, it is usual to take the print away rolled up inside a tube for protection.

Frequently you see a framed print hanging on a gallery wall and when you decide to buy it you are disconcerted to be offered another copy from the plan chest drawer. Today's very high standards of printing means that prints will be almost identical all through the edition, allowing for very minor differences if they are hand printed. Nobody will mind if you scrutinize the one you are being offered.

Doubt about whether a print is the right one for a special position or whether your husband, or person you are giving it to, will like is as much as you do, can be resolved by taking a print on approval. Most galleries will allow this, though they will require a deposit and may put it in a temporary frame for the purpose. A potentially large purchase of a number of prints for a company, university or similar body which operates through a committee will encourage a gallery to lend a portfolio of prints for selection.

When you are buying the print is the time to ask for any information about the print and the artist which has not been freely offered. Any reluctance on the part of the gallery or lack of detailed knowledge should be viewed with concern. Most countries have strict consumer protection laws which govern accuracy of information but the very looseness of some of the terms of reference in printmaking leave them open to abuse.

It is also worth asking the gallery what their policy is towards returned prints or exchanges. Some want to encourage collectors and realize that their tastes may change over the years: they may offer an exchange scheme. In this case it is all the more essential to keep the prints in good condition (see pages 96–106).

Buying at auction is time consuming and subject to the same hazards as selling prints at auction (see page 94). Exceptional bargains are sometimes found but it requires considerable knowledge of prints. There is always a viewing day, sometimes more than one, and it is essential to look at the prints before a sale and sit in on sales to gain experience.

Indirect buying

The collector who does not have the opportunity to visit galleries regularly should consider the possibility of buying by mail order. This is now a well established practice with many reputable companies offering a wide range of prints in their catalogues. They usually publish the prints that they offer and, like Christie's Contemporary Art, their prints can also be bought in print galleries.

The undoubted disadvantage is that small reproductions in catalogues rarely do justice to the original work. The quality of the paper, which is such an important element in a print, is particularly difficult to convey, colours are sometimes distorted and the compression of scale may cause some parts to be under-emphasized.

On the positive side, mail order companies allow one to return the print 'if not absolutely satisfied'. If you are familiar with the work of the artist and know his reputation beforehand you can make reasonably sound judgements. Obviously, the reputation of the company will affect your confidence in them, as with any gallery or dealer.

There have been a number of 'cowboy' mail order print offers which if not dishonest came very close to it and collectors in such cases have been disappointed and misled. Look very carefully at the descriptions given in advertisements and see that they state absolutely clearly exactly what is on offer. If the wording is so ambiguous that you are not clear if the print is an artist's original print or a reproduction (signed or unsigned see page 114), ask for more information and for a full catalogue of all their publications to enable you to build up a better picture of the company which should clarify the position. Offers which promise that they are an investment for the future are best avoided – nobody can truthfully make that claim. Prints by artists now dead, particularly if they are famous and the prices seem very low, are probably re-strikes (see glossary) or may be clever reproductions designed to deceive. In general it is wiser to stick to companies who have a good name and who have been dealing long enough to prove their genuine concern for art, collectors and artists. Print clubs which offer a number of prints each year have flourished for some time; in Scandinavia print buying clubs formed by Trades Unions or the employees of corporations have been popular for many years. Some help to raise money for printmaking studios, others function like book clubs. They offer good value but limited choice.

Information which should be available

Certain basic information should be readily available to the print buyer but the whole field of artist's prints is confused by loose definitions and vague terms. There are doubtful editions and occasionally fakes, though these only appear in the most expensive price brackets. More important is the reproduction which is passed off as an original print. To some extent only the buyer can judge if a print is what it is made out to be but he can only make a reasoned appraisal if armed with all the facts. There is no ultimate solution to the equation of value versus desirability.

The following information should be available:

Artist not only should the artist be clearly named but a short biography should be available. You may wish to follow his career, find other of his works in public collections, know something of his background and likely potential. There may be books and articles on his work which you will want to find and which will help you to a fuller appreciation of his work.

Title most titles are merely for identification but for some artists they are an important element of the work. They may be a deliberate clue to the artist's intention and offer the key to a complex work. A title in the form of a number, for example XIXb, may show that it is to be seen as part of a series or just that there is no literary significance at all for the artist.

Signature catalogues will often identify the nature of an artist's signature: full name, surname or initials and its position on the sheet.

Edition the size of the edition will obviously be of importance. If a very large edition (over 250) has been printed, rarity is unlikely to be a factor in its future value. Some collectors, and artists, feel strongly that smaller editions are to be preferred. The number of artist's proofs and *hors commerce* proofs should also be known.

Date the date is not always written on the print but it is important to know when it was executed in the career of the artist. Occasionally a double date is seen, for example 1958–1979. This means that the artist started work on it at the first date but it was not completed until the second.

Publisher many prints are published by the artists themselves so there are no catalogues or other sources of information. If there is a named publisher they usually document all their prints fully. In many cases the name of the publisher is a guarantee of quality and authenticity.

Printer where an artist has collaborated with a printer it is reasonable to be told so. It is known that in some cases printers are prepared to do all the work and this will eventually detract from the interest and value of the print. In other cases collaboration with a master printer gives the work added interest.

Medium it is not always easy to guess the medium used, especially when the print is framed. Thin screen inks can look remarkably like lithography. No one medium is better or worse than another, only the way in which they are used and for this reason the collector should extend his knowledge of technique

Paper the paper on which the image is printed can be of great significance. Multiple editions are sometimes pulled on more than one sort of paper. European publishers often print an ordinary edition of, say, two hundred copies on a standard paper and fifty more copies on a rare and interesting paper. This will affect the rarity value of the print.

Size the size of both the image and the paper can be significant in identifying a print which has been issued in more than one form in a multiple edition, or where an artist uses one title frequently so that confusion arises. If the paper has been trimmed it may affect the value of the print (see page 110).

This information is essential for two basic reasons: so that the collector can get the fullest enjoyment from the print, knowing about the artist and how the print has been created and also so that he can judge the present and potential value. If disposing of a print in the future the collector is likely to get a better price for it if all the relevant information is available and can be checked.

If the information is contained in a catalogue issued by the publisher it does not need to be repeated on a receipt but it is best to keep both for future reference. They may be an important factor in re-sale or exchange at a future date. Many print galleries take prints directly from artist-publishers and they should have obtained all the details from the artist.

Some publishers issue a certificate of authenticity with each print which usually lists the essential information. There is no legal requirement to do so but many publishers have done this to allay public worries about the authenticity of the prints that they publish. Regrettably, some print galleries do not bother to obtain all the relevant information but they should be encouraged to be more professional by the public demanding it each time a print is bought.

Collecting for investment

Art, for many people, is just a commodity like real estate or shares and they manipulate it in much the same way. Because of these, I feel, misguided attitudes the most common question put to a print seller is whether a print is a good investment. The high auction prices for Munch or Picasso are the exception rather than the rule, though investing in prints has been as good an investment as any other contemporary art form. A print from David Hockney's suite *A Rake's Progress* in 1963 has risen in price tenfold in as many years. On the other hand at print auctions at Sotheby's in 1977 there were losses made on most prints by artists whose prices had been artificially inflated during the print boom. Safe investments in prints can be made, generally in a very small number of famous prints for a great deal of money.

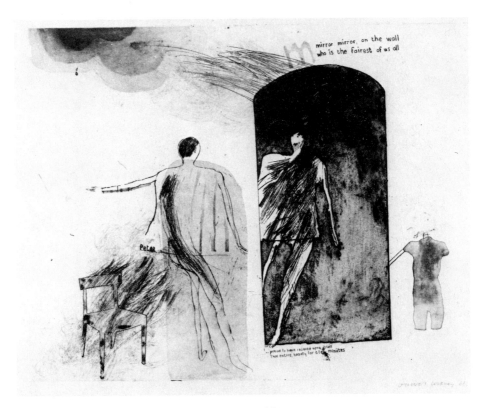

Mirror, Mirror, on the Wall, David Hockney, etching

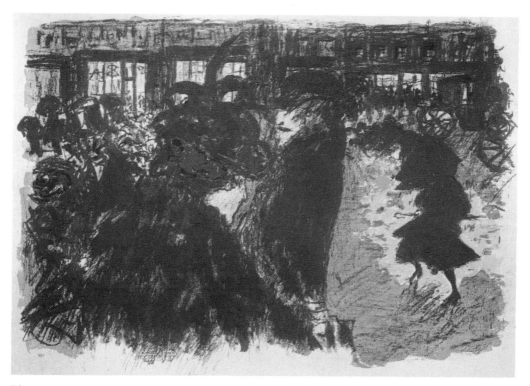

Place le Soir, Pierre Bonnard, lithograph

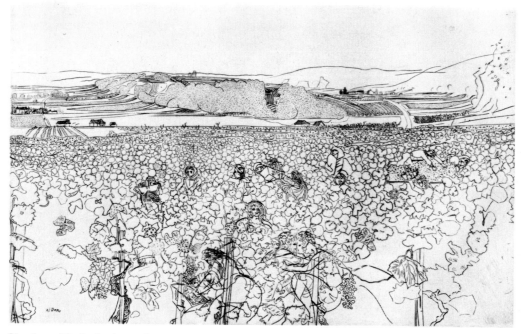

Vendange No 2, Anthony Gross, etching

The pleasure of collecting prints

Prints can of course be bought as investments or speculation but the real pleasure in collecting contemporary prints lies in the collector's involvement with a particular art form, while decorating the home or office, and feeling reasonably sure that the value will at least be maintained. With the exception of a few, over-priced by some dealers, most prints have kept pace with inflation.

The collector may have the luck or judgement to discover an artist at the beginning of his career or find an important print in an unlikely, out-of-the-way gallery or shop. Interest in work of previous periods and styles seems to go through cycles and the collector should be prepared to keep work for a certain length of time and will probably do well to collect to a plan. Collecting work by the leaders or initiators of a well-defined movement such as Pop Art or Minimalism is one possibility or to keep to one artist or one group and try to make the collection as comprehensive as possible. Prints are almost always cheaper when first published – as the edition sells out the price is often raised. If a print appeals to only a small section of the public it may take years for the edition to be sold and so may still be listed years later.

It does not necessarily follow that a more expensive print is a better print. Many factors enter into the pricing of prints though it is basically market forces that rule eventually. Factors taken into account are the cost of materials (size of paper, number of colours etc), size of the edition (most of the cost goes into the preparatory work and larger editions spread these costs), the status of the artist and the fees or commission he commands. Some prints appear to be very expensive but it may be because the publisher has generously given the artist *carte-blanche* to make an experimental print with the assistance of highly paid technicians. Where there are middle-men between the artist and the buyer it is well to remember that the artist sometimes does not get more than ten to fifteen percent of the price you pay. This, of course, has to be balanced by the investment of the publisher, which may be tied up for several years if the artist has promise but has yet to make his reputation. The real enjoyment of print collectors lies not in the value but because printmaking is still largely free from the stultifying effects of academic and art establishment approval and is as a result lively and experimental. It is not necessary to spend large sums of money to start a collection and a change of interest or taste is not inhibited by previous aquisitions. Collecting contemporary original prints is so enjoyable because it allows the collector great flexibility of approach.

Training the eye

Whatever the motivation for collecting artist's prints, every collector should have at least a basic knowledge of the subject, it will increase his enjoyment of prints and give confidence when making a decision to purchase prints. The eye can be 'trained' by looking at prints, old and new, in museums and galleries, where basic information, such as the artist, school, date, style and medium, can also be ascertained easily. Simple curiosity will then lead the collector to extend his knowledge. This will necessitate reading some general art history and perhaps the biographies of specific artists; it may also include finding more detailed information about some techniques and maybe going to see a printmaking demonstration at a print studio or art school. Technical manuals designed for artists are not recommended for the collector who is just beginning to investigate the subject as the very detailed information will probably confuse.

Man in a Deck-Chair, Terry Willson, aquatint with hand colouring

Selling prints

When selling prints two things are important, firstly that the prints are in good condition (see pages 95–106) and secondly, that the seller has the original invoice or receipt and all the details (see pages 88–89) about the print so there can be no doubt about what it is and by whom.

An arrangement may have been made with the original seller that they might buy the print back or make an exchange, so it is worth asking them first what they will offer for the print. It must be remembered that if the gallery re-sell it their price has to include their profit margin so they may not feel able to make a very generous offer but if the print has been very popular and the edition is sold out they are likely to be more enthusiastic.

When approaching another dealer or gallery it is wise to choose one who shows the same sort of prints both in price range and style. Time can be saved by writing to the dealer with a full description of the print. Even if they are interested, however, they will also take into account their re-selling profit margin. Prints can be sold at auction but the average collector is not as well placed as the art dealer who is an expert in timing and placing works in auctions. For the non-expert an auction is something of a lottery, depending to a large extent on luck. Some auction houses have one or two special print sales each year and others sell prints in general sales. The former are to be preferred if the print is of great interest but average works rarely fetch good prices. Some auction houses today also take a premium from both seller and buyer. It is a good idea to put on a reserve, a lower price limit below which the print cannot be sold. All auctioneers have to publish their terms of business but anything you find confusing is well worth discussing with their print expert. They can advise the best time for a print to be sold and also the setting of the reserve; it is in their interest also to get the best price possible.

Another way of selling prints is by advertising them in the specialist press, art journals or the best daily, Sunday or weekly papers. As much information as possible must be given: artist, title, price, medium, date, edition size, number of colours and overall paper size. The smaller dealers as well as other collectors tend to respond to such advertisements and advertising will reach a wider public than by selling direct to dealers.

Helix, Rosemary Simmons, lithograph badly damaged

Framing and conservation

The care of prints

It has been noticeable recently that our museums and art galleries have dramatically reduced the amount of light used when exhibiting any works on paper. Scientific investigation has revealed that these are particularly vulnerable to conditions which are taken for granted as an inevitable part of twentieth century life: pollution of the atmosphere, bright lights and central heating. These findings affect all prints as well as drawings and watercolours. The problems must be appreciated before a solution can be found.

Light is a major factor in the deterioration of paper as it affects it progressively and irreversibly, gradually provoking a chemical reaction which turns paper brittle and changes the colour not only of the paper itself but also the colours printed or painted on it. This can be demonstrated by leaving a newspaper in the sun, it very soon becomes discoloured and crumbly. Artists have always taken a keen interest in different papers and are well aware of the detrimental effect of sunlight but knowledge of artist's materials is now rarely taught in art schools and art suppliers have been replacing traditional materials with untested synthetic ones.

The light rays at the ultra violet end of the spectrum are more damaging than the others. Prints should not be hung in direct sunlight. Fluorescent tube lighting emits considerable amounts of ultra violet light whereas incandescent or tungsten bulbs, still the commonest form of domestic lighting, are safest of all. It is a question of degree: strong light induces damage more quickly, weak light takes longer.

Heat has two damaging effects: it dries out the natural moisture content of materials such as paper and wood and indoors it tends to create rising draughts of air which carry dust and polluted air into framed pictures where it is trapped. Damp is equally dangerous as it will cause the growth of mould, reveal any impurities in the paper (which cause the brownish spots known as foxing) and eventually completely rot the paper. Damp walls are one hazard but there are areas which suffer from excessive humidity at certain times of the year. If it exceeds 70% or goes below 30% paper will be at risk. Some insects are partial to eating paper and pigments and these also tend to flourish in areas of high humidity.

Apart from natural hazards the prints can be damaged by bad framing either using materials which harm the work of art or because the artist used poor quality paper or dangerous glues when sticking other materials to a collage print. Even the best and purest paper is eventually contaminated by being in contact with materials which have a very high acid content or contain other noxious substances. Artists have been experimenting with new

materials, the behaviour of which in the long term nobody yet knows. We do know that many of the adhesives in general use are harmful: these include cellulose tapes, masking tapes, pressure-sensitive adhesives and rubber gum, all of which discolour and eventually rot even the best papers.

Museum conservationists have said that, ideally, works on paper should be stored away from light and be kept in an air-conditioned, temperature-controlled environment, and that all materials in contact with a print or other work on paper, should be acid free and that there should be no points of pressure or restriction of the natural movement of the paper.

This can be a very daunting prospect for the amateur who does not live under museum conditions, but a certain amount can be done to follow their advice. Conservationists in museums have a special duty since they keep works of art on the public's behalf and they must preserve them in the best possible way. The individual collector is strictly responsible only to himself, though some hold the view that all art is for everyone and the collector holds it only in trust. Collectors who plan that their acquisitions will eventually be accepted into public collections on their death have a responsibility similar to curators. Most collectors will have to make up their own minds, and again it is a question of degree since the framing of an inexpensive print, done in the correct way, will cost far more than the print itself.

There are, however, some basic rules which if followed will minimize damage, even if the collector cannot maintain ideal conditions. Most houses now are centrally heated, if not air-conditioned, and collectors of antique furniture will already be well aware that some means of humidifying the atmosphere is desirable for the well-being of the wood; paper appreciates the same conditions.

The basic rules for print preservation are:
1 do not hang a print where it will catch direct sunlight.
2 do not hang a print over a heater, radiator or hot air duct.
3 do not fix a light immediately over or close to a print.
4 do not attach a print to any other material by irreversible means.

Framing

Framing is intended to protect as well as display a print or picture to best advantage but the drawbacks of various sorts of framing should be understood. There are basically three sorts of framing from which to choose: (1) framing according to the highest conservation standards, even though this is expensive. (2) sensible framing which gives reasonable protection but which cannot be considered permanent and should be reviewed after about ten years. (3) temporary framing which gives little protection.

Obviously, the value of the print will play a part in the decision as to which type of framing to choose. A valuable print should be framed to the highest standards but an inexpensive print is rather different. Sensible framing will keep it in good condition for some years but it should probably be re-framed after that time. Temporary framing should not really be used except for posters or similar reproductions.

A frame to conservation standards is made up of a number of layers:

Glazing use good quality picture glass or Perspex VA or VE (Britain) Plexiglas UF1 or UF3 (USA) which is treated to exclude most of the damaging ultra violet rays. Never use non-reflective glass as this only works when in direct contact with the print and this is to be avoided. Under certain conditions the inside of the glass can be subject to condensation which will affect the print, so a pressure gap is preferred which also allows some natural movement to the paper.

Mount or mat the purpose of a window mount is to keep the print away from direct contact with the glass. The mount should be cut from acid-free 100% rag conservation board with a neutral pH of 7. The size of the window should allow the image and the signature to show. The overall size of the mount must be larger than the print so that this does not touch the sides of the frame or moulding when it is assembled.

Print this is placed behind the window but not attached to the mount.

Backing mount or board a sheet of conservation board is placed behind the print, which is hinged onto it. The hinges should be made of an acid-free long-fibred paper, such as hand-made Japanese paper, and should be glued with an acid-free starch paste.

Barrier it is recommended that a barrier should next be placed to isolate the print and its immediate mount from the frame back. A sheet of inert plastic made of polyethelene terephthalate known as Melinex (Britain) or Mylar

Primitive Hive II, Graham Sutherland, aquatint

(USA) is ideal and will prevent the migration of noxious substances from the backing and outside air.

Frame back board a good quality board or hardboard (masonite) is recommended.

Seal conservationists disagree as to whether the gap at the back of the picture between the back board and the moulding should be sealed with linen tape or filled with a strip of cotton felt to allow the print to breathe but to exclude dust. In a city, where there is air pollution, it is probably better to seal the gap with tape.

Moulding the choice of a wood or metal moulding is largely an aesthetic one as neither come into contact with the print to affect it directly. The choice of mouldings is obviously very large, from reproductions of eighteenth-century gilded frames, Victorian oval frames to plain or painted wood and brass, aluminium and stainless steel. Metal frames can be finished with shiny, matt or painted surfaces and there is both real and imitation gilding of wooden frames. Plastics are also used to make boxes and other constructions to hold prints.

Prints which have no margins when the image extends right to the edge of the paper or a feature is made of the deckle edge of the sheet and a window mount is inappropriate, the print can be invisibly hinged onto the backing mount. A thin spacer or fillet of Perspex or thick conservation board is put between the glazing and the edges of the backing mount to keep the glazing out of contact with the surface of the print.

Coloured or fabric mounts museum conservation board is usually only available in an off-white colour. If a decorative, coloured mount is required paper or fabric can be glued, with an acid-free paste, onto the upper surface of the window mount where it will not be in direct contact with the print.

Sensible framing can be far less elaborate if the collector is aware of certain hazards and watches out for them. A sensible frame will be composed of glazing, mount, print, barrier, backing and moulding. It is worth insisting on good quality picture glass, if only to avoid surface distortion, though ordinary quality Perspex or Plexiglas is acceptable. If no window mount or spacer is used to keep the glass away from surface of the print, signs of condensation inside the glass should be watched for and the print removed from the frame if this occurs. The mounting boards generally available are not acid-free like conservation board and will, eventually, affect the print. If the cut edge of a mount made from such board starts to turn orange the acid level is high enough to damage the print and it should be removed at once. This process

Rush, Michael Rothenstein, relief and screenprint

can take a number of years but, as already stated, damage to paper is irreversible, though sometimes staining can be removed but this is both difficult and expensive (see page 106).

The means of fixing the print in position is important. The framer should not fix the print by an irreversible method. Prints should not be stuck down, either all over or round the edges, as, apart from chemical action on the paper, it prevents the paper breathing and could cause it to tear. Acid-free pastes are widely available and should be used, but only the smallest amount on the two top corners is necessary to keep the print in position on the backing. Some framers use small pressure pads to hold the print in place, these can slip but are safer than other forms of fixing. A sheet of acid-free paper placed behind the print gives some protection and is not so expensive as conservation board. Old fashioned backing of plywood or thin wood board was always more dangerous than paper board but the cheapest paper boards should be avoided if possible. The gap at the back between the backing board and the moulding can be sealed with gum strip which will keep out the dust but it should be remembered that the glue is usually acidic. The choice of moulding is again simply a matter of personal choice. Unless an acid-free mount is used and the print kept out of contact with other pollutants some damage will be taking place, even if it is not apparent to the eye. It is reasonable to review any print after, say, ten years and if the collector wishes to keep it permanently in his collection is is probably worthwhile getting it re-framed using conservation approved materials.

Temporary framing varies from a 'sandwich' of glass and backing held together by clips, to lengths of plastic or metal moulding which are joined at the corners by patent devices. The disadvantages of these systems is that the print is in contact with the glazing and the backing board and that dust and polluted air can come in at the sides and in the gaps at the back.

Not all framers will be experienced in handling prints. Once the type of basic frame has been decided on it is essential to discuss it fully with the framer to ensure that the instructions will be carried out. There are some rules about handling prints which every framer should know: (1) never cut the paper of a print as it could reduce its value and is contrary to the intention of the artist who will have chosen the margins and the relationship of image to sheet size with care. (2) never fix the print by means of any tape or glue other than acid-free paste. (3) never heat-mount the print onto a board and never heat-seal the surface with a plastic film. (4) handle the paper with care, picking it up with both hands, one on each side of the sheet. Paper creases and kinks if not held properly and such marks are impossible to completely erradicate.

Do-it-yourself framing

There is no reason why the collector should not do his own framing to the highest conservation standard if he has a few simple skills. Acid-free papers and boards are much more widely available now that the care of paper is becoming generally appreciated. The plastic sheets which filter out ultra violet light (see page 98) are not generally found in small sizes or cut to measure, but no doubt will become more widely available as people require it from framers and craft suppliers. Acid-free paste for use in hinging the print can be made by cooking ground wheat or rice flour with a little water in a double saucepan for about thirty minutes. Mouldings can be bought cut to your requirements or in standard sizes.

Maravillas Acrosticas No 14 Joan Miro, lithograph

Other ways of conserving prints

Conservationists have said that ideally prints should be kept in a dark, dry place with the temperature thermostatically controlled. Curiously enough in the eighteenth and nineteenth century this is almost exactly what was done in the libraries of the large town and country houses. Libraries commonly housed prints and drawings as well as books. The bookshelves round the walls provided excellent insulation from the excesses of heat and cold. In the centre there was usually a print stand on which portfolios were stored and displayed. There would have been a large table on which to lay prints and, perhaps, deep shelves on which to store bound albums and solander boxes. New acquisitions were shown off to friends and avidly discussed. Many collectors subscribed to the publication of suites of prints which were issued in groups, often at six monthly intervals, and were eagerly awaited. White cotton gloves were kept in case a guest should arrive without gloves (though they were commonly worn indoors at social occasions) and wish to look at prints. Thus prints were protected from the acid oils which are present on the finger tips and do eventually harm the paper.

This tradition of handling prints would be well revived but as people no longer wear gloves indoors it would be a good idea to keep several pairs of cotton gloves for the purpose. One tends to ignore works of art hanging on the wall after a period of time, they become part of the furnishing of a room, and loose their visual freshness. A work that you look at only occasionally keeps its excitement as well as preserving its physical condition.

Few people now have a special room which can be specifically devoted to prints but there is almost always room for a portfolio or for print storage in boxes and chests. Portfolios are the most generally used form of protection for unframed prints. Basically a portfolio consists of two flat boards, hinged with linen or some other fabric. It has flaps at the sides which are usually tied with tapes to keep the contents from falling out. They come in various sizes, based on the traditional hand-made sizes of paper – royal, imperial and antiquarian (see glossary). The portfolios which are available in art supply shops and stores and generally used by artists to keep all types of paper together are usually made of card and board which has a distinct acid content. They must be regarded as potentially dangerous to prints stored in them and certainly expendable.

Special suites of prints are often published in portfolios designed for the purpose. These are sometimes very elaborate and contain original designs by the artist concerned. They are frequently constructed of exotic materials such

104

as skin, silk, velvet, rare woods and metal sheet inlaid, embossed, printed and with other substances incorporated in a collage. More conventional portfolios are covered in book binder's cloth and have the suite title and the artist's name blocked on the front. Such portfolios are made by book binders and can no longer be relied upon to be made from safe materials. The insertion of a sheet of inert plastic (see page 98) or acid-free cartridge paper between the prints and the back and front of the portfolio boards will give considerable protection. This should also be done in the case of ordinary portfolios from art suppliers the construction materials of which are equally unknown.

Solander boxes are smaller than portfolios and rarely exceed twenty by fifteen inches. They have rigid sides usually about three inches deep and open out so that prints or drawings in one half can be slid sideways into the other half with the minimum of handling. They are in general use by museums for print storage. Each print is mounted using conservation board (see page 98) for the backing board and the window mount in front. A sheet of transparent inert plastic is sometimes inserted behind the window to give further protection to the work of art. Prints kept this way are never directly touched by unprotected fingers. Solander boxes are usually specially made to measure by book binders.

Large books or albums of blank sheets were another traditional way of keeping prints and drawings. Contemporary prints have tended to be rather too large to store in this way but some collectors who have a number of small prints which tend to get easily damaged might revive this method. They too would have to be specially made by a book binder. Acid-free paper would have to be used and the prints hinged onto the blank sheets with acid-free paste (see page 102).

Artists also use plan chests with large, shallow drawers to store their prints. They are generally designed for architects and can be handsome pieces of furniture in their own right. The hazards of lifting large sheets of paper in and out of plan chest drawers can be avoided by using large sheets of conservation or ordinary mounting boards between prints or shallow layers of prints. The boards can also be simply hinged, like a portfolio to keep prints in manageable sets. Prints should be interleaved with acid-free tissue or stronger paper for protection.

Damaged prints

Prints that suffer damage from over exposure to light which discolours the paper and bleaches the image cannot be revived. Tears, creases and kinks in the paper can sometimes be repaired, or diminished but this should never be attempted by the amateur. Trained paper restorers use methods and materials that are approved by museums, who are usually helpful in recommending a suitable restorer. Some stains can be removed but again only a trained paper restorer should attempt such a repair.

Transport of prints

Prints and drawings are probably the easiest works of art to transport but there are some methods which are to be preferred. Prints are most often packed in tubes and it is very important to use a tube of sufficient strength, the wall of the tube should not be less than $1/8$in. thick. Equally important is that the tube should be of sufficient diameter so the print is not too tightly rolled, the tube should not be less than three inches across and four inches is preferable. To protect the ends of the print the tube should be long enough to extend at least two to three inches beyond the rolled print. The print should be placed face up on a sheet of acid-free tissue paper and another piece of tissue placed on top. It should then be rolled up so that the roll is just less than the internal diameter of the tube. Another piece of tissue is then rolled round the print to prevent it unrolling to rub against the tube sides. Pads of crumpled tissue each end of the tube will prevent the print moving about inside it. Some tubes have fixed ends or caps, if not a round piece of card should be cut and taped over the ends.

Most prints are rolled with the image facing in but screenprints with heavy layers of ink should be rolled with the image facing out, like an oil painting. Not all prints should be rolled. Those with deep embossing or very thick ink must be carried flat between boards. Prints should be rolled for as short a time as possible and allowed to flatten under a board. To remove a print which has unrolled in a tube grasp the inner corner of the print and twist gently towards the centre and withdraw.

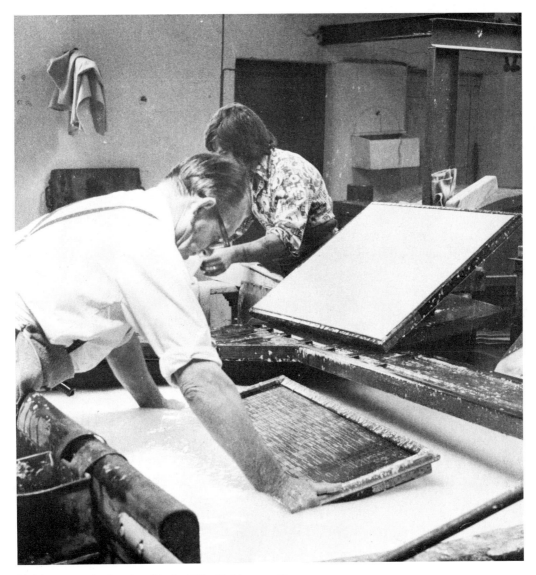

Making paper by hand at Hayle Mill, Maidstone, Kent

Paper for prints

Paper for printmaking

Paper is an integral part of the print, although we tend to concentrate more on the image itself. Artists work with papers of all kinds and must be aware of the very variable properties of this versatile material. It can have remarkable strength when wet and it can also be made transparent by oiling and indeed is used for windows in the East.

Paper is made from a pulp of cellulose fibres (wood or other natural fibres being commonest) suspended in water which is allowed to settle into a felt which is then dried. Early Chinese sources say the first paper was made from scraps of silk, others claim old rotted fish nets were first used. Papyrus is not strictly paper although our word for paper comes from the beaten pith of the sedge plant from which it is made. The basic natural materials used for the pulp provide the various colours, textures and behaviours of paper which the artist takes into account when choosing a paper for a particular image. Artists have made prints on other materials: vellum (skin of new-born calf), fabrics, metal sheet and plastics but paper has proved the most versatile and durable.

Hand-made paper is the best because it is pure and strong. Old linen and cotton rags were the main ingredients for the pulp in Europe whereas oriental papers were, and still are, made from the inner bark of various trees like the mulberry. The main source of material for paper is now cotton linters, a by-product of cotton spinning mills.

Whatever the source of the fibres they are first softened by beating in water and are then scooped up into a rectangular, porous 'mould' by the vatman. He distributes the pulp evenly by sideways shaking of the mould, causing the mat of fibres to interlock, while the excess water drains through the wire-mesh bottom of the mould. The now-formed sheets are tipped onto wool felts by the 'coucher' and piled up one on top of the other. The pile is then pressed to express more water and the sheets are slowly dried and matured. It is a trade with many traditions and much regard for the nature of its pure water supply as well as for the weather. One mill in Britain refused to make paper in August; the wind was always in the wrong direction!

Paper can be made from most vegetables and plants and amateur paper-making thrives with the help of the kitchen mixer for the beating. Artists have also been experimenting with paper pulp to make 'formed paper prints' (see page 59).

Making paper by hand is a slow process and a mechanical method was invented in the eighteenth century in which the vatman's flat mould was replaced by a cylinder shaped mould which revolved in the vat of pulp. Most

mould-made papers, as these are called, are made of the same raw materials as hand-made paper and are of high quality. They are very popular with print-makers as they are less expensive than hand-made paper and have an even regularity which is important where mechanised printing is used. The fibres are less interlocked than in a hand-made sheet so the paper is rarely as strong.

The vast bulk of papers are machine-made on a Fourdrinier machine, developed after the mould machine, which uses an endless web on which the pulp is deposited. The pulp is usually cellulose derived from wood which contains a high proportion of chemical impurities and has short fibres which make a paper with little strength and a short life. The paper industry generally makes paper and board on the premise that it is not required to last, hence the importance of the choice of paper.

Printmakers who eschewed all manual techniques in their desire to relate to the modern industrial world turned to machine-made papers with their anonymous character. There was also a technical reason: photo-images utilizing the fine halftone dot screen (see page 71) could only be printed satisfactorily on those smooth papers developed for commercial printing. Unfortunately neither artists nor publishers realized that these papers had an uncertain life span.

Textures and edges

Artist's papers are made with various surface textures: rough, 'NOT' and hot-pressed. The natural drying of the fibres gives a rough surface on hand-made paper, accentuated by rough felts in mould-made paper. Hand-made 'NOT' paper is pressed between boards to reduce the texture, mould-made uses fine felts. Hand-made paper hot-pressed between sheets of polished zinc has a smooth surface; mould-made paper is also pressed to make it very smooth. Machine-made papers are usually given textures by rolling (calendering) with smooth or textured rollers. 'Art' papers used for fine reproductions in books have a surface of china clay and many very white-looking papers are coated with 'optical brighteners' which absorb ultra violet rays and emit them as blue rays thus increasing the apparent whiteness. The long term behaviour of these and other treatments is not known.

The most common finish to paper used by printmakers is that of gelatine size (see glossary). This is added either to the pulp or coated on the sheet after

preliminary drying. The effect is to harden the surface of the paper and to strengthen it when damped. Lithography and relief printing is generally done on paper with little or no size; intaglio printing uses paper with size as does screenprinting if a smooth sheet is wanted.

The feathery edge round a sheet of hand-made paper is called after the detachable frame or deckle round the mould, under which a small amount of pulp seeps. The deckle varies in size depending on the fibre length of the pulp. The natural deckle is imitated in mould-made paper by the pressure of a rubber strap or water jet along the length of the paper. The deckle shows only on the two short sides of the sheet, the two long sides are torn edges where the sheet is detatched from the web. Machine-made papers always come with clean, guillotined edges.

Some artists insist that the deckle is an integral part of the sheet, not only to prove the quality of the paper, but also for its aesthetic value. Other artists prefer to cut off the deckle on hand- and mould-made papers for two reasons: they may wish to deny the 'hand-made' character of the paper or it may be necessary to trim the edges absolutely at right angles to obtain accurate registration of colours (see page 72) as mechanized printing machines cannot easily handle sheets with uneven deckle edges. A deckle edge should not be cut off the print by the collector (see page 89) if the print is to keep its value.

Watermarks, stamps and chop marks

The watermark in a sheet of paper can be seen if the sheet is held up to the light. A design is made out of wire and fixed to the mould mesh, leaving a thinner layer of pulp over the wire design. The watermark is usually the device of the paper mill and is important in identifying some prints. Paper made specially for a suite of prints often incorporates a special watermark in the form of an artist's signature or publisher's mark.

Blind embossed cyphers are frequently seen in one corner of the paper. They are another means of identification which does not visually affect the image. Most chop marks or embossing stamps are applied by publishers when the edition is completed. Some artists also use a device in the manner of an oriental seal and which may incorporate a phrase such as 'printed by the artist' or 'hand-printed'.

110

The Three Cats, Alstowe, L.S. Lowry, original lithograph

What is an original print?

Original prints

People have commonly used the word original in art to mean a unique work, usually a painting or drawing; sculpture is rather more complicated. The use of the term 'artist's original print', introduced in 1960, has probably created just as much confusion as it was intended to dispel.

The entry in the 1979 *Oxford Paperback Dictionary* under 'original *adj*.' reads: (1) existing from the first. (2) being a thing from which a copy or translation has been made. (3) first-hand, not imitative, new in character or design. (4) thinking or acting for oneself, inventive, creative, *an original mind* (my italics). The third and fourth entries are relevant to the definition of an original print. Perhaps an analogy with sculpture can be drawn. Carvings in stone or wood are unique works but castings in metal, plaster or resin may exist in editions, like prints. A sculpture to be cast is usually first modelled in clay, wax or plaster which serves as the 'original' and is destroyed in the casting process. In the case of an artist's print the 'original' is an idea in the artist's head and not realised until the last colour has been printed to complete the image.

A reproduction is *not* an original print. A reproduction of Constable's *Flatford Mill*, for example, is an inadequate approximation to an oil painting, even when printed on canvas with hand-brushed varnish on top of the reproduction to simulate brushstrokes. A reproduction is a copy (though not necessarily the same size) of unique work. Quality varies from a very crude version many times smaller than the painting, to a facsimile which is the same size, striving to reproduce every tonal nuance of the original. Facsimile reproductions are often extremely good in terms of commercial printing technology but could not be further removed from creative artist's prints.

Historically prints, as well as being a creative medium used with immense skill by such artists as Durer or Rembrandt, were much sought after simply as representations of famous works of art, though such prints have often achieved great fame and considerable value. By the second half of the nineteenth century the print was generally thought of as a reproductive medium which, with the coming of photography and photo-mechanical printing, had little importance.

An artist signing a print was rare until the late nineteenth century, though Durer and others did try to protect their copyright by the use of their own monogram (see the illustrations on page 13). Old prints usually had a series of terms in Latin (see glossary) engraved under the image which identified the artist who designed the print, the craftsman, the printer and the publisher.

Whistler and Seymour Haden, who became the first President of the Society of Painter-Etchers, made a habit of signing prints as part of their campaign to elevate the status of artists' prints. They also tried to find an acceptable definition of what we now call an 'artist's original print' but there were many disagreements; some of which revolved round the use of photography, as not all artists could agree that the camera was in the same category as the pencil or brush.

The need to agree on a definition of an original print was more the result of international trading and import taxes than the desire to protect the collector. In 1960 the International Association of Plastic Arts, a UNESCO affiliate, composed only of artists, met in Vienna and issued a recommendation which said in essence that an original print must be printed from plates, blocks or stones made by the artist himself, must be signed and numbered and the printing matrix cancelled after the edition. The following year the Print Council of America issued a similar recommendation but insisted specifically that the artist must also be the printer. They differed from the IAPA in not making the limitation of the edition mandatory and they allowed most modern printmaking techniques with the exception of direct photography and 'exclusive reliance on photo-mechanical plates' which they said 'were frowned upon by most printmakers'. In France in 1965 the National Committee on Engraving said original prints must be 'conceived and executed entirely by hand by the same artist . . . with the exclusion of any and all mechanical or photo-mechanical processes.' This wholly ignored the fact that a number of the most prestigious French printmakers had long employed craftsmen to collaborate in the production of their work. In common with the definition of the IAPA and of the PCA it also excluded screenprints.

So the splendid and vital new screenprints by Hamilton, Kitaj and many others which involved photo-imagery, and had been recognized since 1962 as an important new art movement seemed to be excluded; something that has only been partially resolved recently.

Import regulations added to the confusion. Canada classified etchings, lithographs and relief prints as 'fine art'; screenprints were not and so were taxed. The United States insisted that prints must be 'autographic'. In Britain, prior to the introduction of Value Added Tax in 1973, an arbitrary edition size of 75 (or even the first 75 of a larger edition) constituted an original print, exempt from tax. France rejected any photo-based imagery, while Australia fixed a value definition. The problem has still not entirely been resolved but the battle to include screenprints and photo-imagery in 'fine art' seems to have been won.

The impossibility of constructing a simple definition which encompasses all the techniques used by artists is obvious. The emphasis has now shifted to

the artist, publisher or gallery to provide the fullest information on which a judgement can be based. Several States in America have adopted legislation which requires 'truth in labelling fine prints'. This applies only to prints made after the law came into force. The Trades Descriptions Act in Britain makes it more difficult for the public to be deliberately misled but the imprecision of many terms used still leaves some loopholes.

The preoccupation with photo-mechanical methods has obscured the real issue. Modern equipment allowed the unscrupulous to produce apparently genuine original prints and it is particularly unfortunate that some artists were prepared to lend their signatures to such reproductions. Most artists and bona fide dealers are, however, rightly annoyed when sellers of such reproductions offer their wares as 'limited edition prints', 'signed artist's proofs', 'collector's items' and 'fine art prints' implying similar value to artists' original prints. Often such offers 'limit' the edition to orders received before a certain date, but this gives the prospective buyer no indication of the total number printed. Many of these 'signed artist's proofs' are printed in thousands, some of which the misguided artist is persuaded to sign. The addition of a signature on some copies in no way justifies the enormously inflated prices. L.S. Lowry added confusion to the situation by making original lithographs *and* signing repro-ductions.

The collector will have to make a judgement in which his pleasure in the work must play a major part, when he buys an artist's print he is acquiring an image of which more than one exists. It is in the collector's own interest to be well informed. Visiting galleries, asking questions and not being put off, going to auctions are part of being a collector. The collector would do well to bear in mind the definition of an original print given by that masterly printmaker Anthony Gross 'a work full of inventiveness, originality and humanity'.

114

Barbara Hepworth lithograph *Mycanae* and print catalogues

Further reading

Books on the background and history of printmaking

Adhemar, Jean *Twentieth Century Graphics*, New York, Praeger, 1971. Comments on some of the most famous prints mainly from the Ecole de Paris

Buchsbaum, Ann *Practical Guide to Print Collecting*, Van Nostrand Reinhold, New York, 1975. A very good list of catalogues raisonnés and an extensive bibliography

Castleman, Riva *Prints of the Twentieth Century: a History*, Thames and Hudson, London, 1976. Based on the superb collection of prints in the Museum of Modern Art in New York

Eichenberg, Fritz *The Art of the Print: Masterpieces, History, Techniques*, Thames and Hudson, London, 1976. Extensive survey of all forms of printmaking with a full bibliography

Gilmour, Pat *Modern Prints*, Studio Vista, London, 1970; Dutton Pictureback, New York, 1971. Still the best small paperback survey of contemporary printmaking

—— *The Mechanical Image: an Historical perspective on Twentieth Century Prints*, The Arts Council of Great Britain, London, 1978. Accompanied a didactic touring exhibition and raises many interesting points

Gombrich, Ernst *The Story of Art*, Phaidon, Oxford, 1978. Praeger, New York, 1972. A useful introduction to art history in the Western world

Hayter, S.W. *New Ways of Gravure* Oxford University Press, London, 1949

—— *About Prints*, Oxford University Press, London, 1962. Two important books by a leading intaglio printmaker which combine comments on technique and philosophy which had great influence in reviving interest in printmaking

Ivins, William M. *How Prints Look*, Beacon, Boston, 1967. A guide to the collector

—— *Prints and Visual Communications*, Massachusetts Institute of Technology, Cambridge, Mass, 1963. Discussion of some of the finer points of interest in printmaking

Leymaire, Jean *The Graphic Works of the Impressionists*, Abrams, New York, 1971. Important survey of printmaking in France in the second half of the nineteenth century

Man, Felix H. *150 Years of Artist's Lithographs 1803–1953*, Heinemann, London, 1953. History based on the author's fine collection – very strong on early lithographs

Newton, Charles *Photography in Printmaking*, Victoria and Albert Museum/Compton/Pitman, London, 1979. Excellent survey of the printmaker's use of photography, originally designed to accompany an exhibition at the museum

Rosen, Randy *Prints, the Facts and Fun of Collecting*, E.P. Dutton, New York, 1978. Excellent, well informed introduction to print collecting

Scharf, Aaron *Art and Photography*, Allen Lane, The Penguin Press, London, 1968. Very interesting survey of the impact of photography on the artist

Steinberg, Saul H. *Five Hundred Years of Printing*, Penguin, London, 1955. Standard history of the development of printing technology

Strachan, W.J. *The Artist and the Book in France* George Wittenborn Inc., New York, 1970

Zigrosser, Carl and Gaehde, Christa M. *Guide to Collecting and Care of Original prints*, Crown, New York, 1965. Standard work on conservation and terms, originally sponsored by The Print Council of America

Books on the technical aspects of printmaking mainly designed for artists and teachers

Biegeleisen, J.I. *Screenprinting: a Contemporary Guide*, Watson-Guptill Publications Inc., New York, 1971

Brummer, Felix *A Handbook of Graphic Reproductive Processes*, Alec Tiranti Ltd., London, 1962

Chamberlain, Walter *The Thames and Hudson Manual of Etching and Engraving*, Thames and Hudson, London, 1962

Gross, Anthony *Etching, Engraving and Intaglio Printing*, Oxford University Press, London, 1973

116

Heller, Jules *Printmaking Today*, Holt, Rienhart and Winston, New York, 1972

Jones, Stanley *Lithography for Artists*, Oxford University Press, London, 1967

Knigin, Michael and Zimiles, Murray *The Technique of Fine Art Lithography*, Van Nostrand Reinhold, New York, 1970

Mara, Tim *The Thames and Hudson Manual of Screen Printing*, Thames and Hudson, London, 1979

Peterdi, Gabor *Printmaking*, Macmillan, New York, 1971

Petit, Gaston and Arboleda, Amadio *Evolving Technique in Japanese Woodblock Prints*, Kodansha International Ltd, Tokyo, 1977

Rothenstein, Michael *Frontiers of Printmaking: New Aspects of Relief Prints*, Reinhold Publishing Co, New York, 1966

Ross, John and Romano, Clare *The Complete Printmaker*, The Free Press, New York, 1972

Russ, Stephen ed. *A Complete Guide to Printmaking*, A Studio Book, Viking Press, New York, 1975

Senefelder, Alois *A Complete Course of Lithography*, 1819. Reprint, Da Capo Press, New York, 1970

Turner, Silvie ed. *Printmakers Council Handbook of Printmaking Supplies*, Printmakers Council of Great Britain, London, 1977

— *Screen Printing Techniques*, B.T. Batsford, London, 1976

Vicary, Richard *Advanced Lithography*, Thames and Hudson, London, 1977

Yoshida, Toshi and Yuki, Rei *Japanese Printmaking: a Handbook of Traditional and Modern Techniques*, Charles Tuttle, Rutland, Vermont and Tokyo, 1966

Other sources of information

The biography or autobiography of a famous artist will be of interest for collectors concentrating on particular artists or movements. Their works may be analysed in a critical monograph or might be included in a general study of the period. These books, and the ones listed on the preceeding pages, are generally easy to locate and should be available in bookshops though public libraries may have them if out of print.

Other publications may only be found in museums or specialist libraries. A useful source of information are the catalogues of print exhibitions or those issued by print publishers. They are, however, rarely collected consistently by libraries who tend to rely on the catalogue publishers to send copies for the archives. Catalogues raisonnés are usually available as they are formally published catalogues giving a complete list of an artist's work. A catalogue raisonné may also list items in a specialist collection or a publisher's total output. They are of particular importance to collectors and print dealers for they give the fullest known details of every work and are used to identify works and establish their authenticity. Catalogues raisonnés of the work of individual artists naturally exist only on the major artists.

The general press rarely reports developments in printmaking and art critics still neglect it as a subject of interest. Some specialist art magazines cover print exhibitions regularly: *Art News* in America and *Arts Review* in Britain are most useful in this respect. *The Print Collector's Newsletter*, published bi-monthly in New York, has useful articles, reviews and information on prices. *Artist's Proof*, now called *Print Review*, has been published for many years by the Pratt Graphic Institute in New York and back issues are useful and can be found at a specialist library. *Nouvelles de l'Estampe*, published six times a year by the Comité National de la Gravure Française in Paris covers new acquisitions to the Bibliothèque Nationale and general print activity internationally. The catalogues issued by the international print biennales such as those at Ljubliana, Crakow, Bradford and Tokyo, are mostly well illustrated and give a good view of national trends.

Many museums have fine collections of historic and contemporary prints which can be

studied. They usually exhibit part of their collection, taking a theme or focussing on one artist, while the rest of the collection remains stored in boxes in the 'print room' into which the public can sometimes go by appointment. In the past members of the public have been deterred from using these collections but most museums now are more approachable. The print rooms are not, however, designed for the casual visitor who has only a vague idea of what he wants to see. The collection catalogue should be checked first to identify exactly what you want to see. The staff will explain the organization of the catalogue and how you put in a request. Prints are generally kept in solander boxes and albums, which will probably have to be located in a store room and brought to your seat in the print room where you can study them in detail. Museums with a technical or applied art bias may have displays on general or specialized printing methods and arrange demonstrations of printmaking. Many museums set aside a particular time when they will identify works which the public bring to show them, but do not give valuations. The major auction houses will give you an idea of value if you want to sell a print. They also undertake valuation for insurance and probate but will charge for the service.

Practical studies

Not all printmaking requires a heavy press or a great outlay on equipment and there is no reason why the interested collector should not experiment with making prints himself. Explanations in books can give some idea of technique but cannot really convey the physical sensation involved. Some understanding of what it is really like to cut wood, mix ink or print using a screen adds another dimension to the enjoyment of prints of all sorts. The amateur is never a threat to the professional – he appreciates the skill and endeavour all the more. Some printing, such as relief printing, can be done by burnishing and the most sophisticated Japanese woodblock prints are created without a press using simple materials and tools. Screen printing is equally easy at home using widely available materials.

At a more advanced level art colleges and art centres offer facilities for part-time students, and some of the studios set up by artists themselves offer tuition.

Other sources of information are the art societies which exist to foster a special interest in, for example, etching and engraving. They usually have annual exhibitions and frequently issue a news-letter of general interest. Most of them welcome non-practising members in an associate capacity.

Glossary of terms

Acid corrosive liquid used to etch metal plates: nitric, hydrochloric, ferric chloride, cupric chloride and potassium chlorate are all used. Also called the mordant. Various acids are used in lithography to re-sensitize areas and as a grease solvent. An alkali, caustic soda, is used in solution to etch lino

Acid-free neutral pH state usually in reference to paper, board or paste (see page 98). pH is expressed on a scale 0–14 ranging from alkalinity to acidity: pH 7 is neutral

Affiche originale used in France to denote a poster created by an artist, usually for his own exhibition, often signed and numbered. Usually lithographs or screenprints

Aluminium used for litho and intaglio but more difficult to use than traditional metals as it oxidizes very easily. Most photo-litho plates are aluminium or aluminium alloys

Antiquarian a size of paper used by printmakers approx. 790 x 1350 mm (31 x 53 in.)

Aquafortis (*Latin*) nitric acid. Acquaforte, *all' acquaforte* being the Italian for an etching

Aquatint intaglio technique to obtain the impression of tone (see page 63)

Artist's books a book totally designed by the artist and produced in small editions using printmaker's techniques. Often a collection of prints with supporting text issued on subscription. A strong European tradition

Artist's proof *or* **AP** copies of a print over and above the edition (normally not more than ten percent extra) pulled for the artist's archives and friends (see page 77)

Autographic a print on which all the work has been done by the artist alone

Autolithography hand-drawn in contrast to photo-lithography

Authorized edition see Estate print

Avant les lettres on old prints the state before the title, artist and publisher were engraved beneath the image. The state before editioning

Baren Japanese burnishing pad made of twisted string or wire between varnished cloth covered with bamboo sheath

Bite the action of acid on a metal plate in etching

Blanket 1 felt placed between the roller in an etching press and the paper which is forced into the intaglio section of the plate. 2 rubber, or similar, covered rollers on an offset litho press

Bled image when the image extends to the edges of the paper or when the paper is trimmed into the printed area i.e. no margins are left

Bleeding colour pigment which spreads beyond the printed area to leave a discolouring 'halo' effect on the paper

Blended colours when two or more colours are blended by a roller or squeegee; also called rainbow or merged colours. In mechanical inking called split duct or fountain

Block book an early book in which the makeup of each page or pair of pages is carved from a single piece of wood: type and illustration together

Blue print paper impregnated with light-sensitive solution used to make negative copies of plans or drawings. Soon discolours. Occasionally used by artists

Bokashi Japanese term (see page 46)

Bon à tirer *or* **BAT** (*French*) written on a proof to indicate that it is passed for press or ready to be editioned (see page 75)

Burin 1 engraving tool used for metal and end-grain wood (see pages 60 and 64). 2 interchangeable with 'engraving' to describe the typical line which results from engraving

Burnishing 1 applying pressure by rubbing on the back of paper laid on an inked relief block. 2 rubbing down the texture on an intaglio plate (see aquatint on page 63 and mezzotint on page 64)

Burr the ridge of metal on either side of a drypoint line (see page 64) which holds ink to produce a velvety line. The burr wears down rapidly unless the plate is steel-faced

Cancellation proof a pull which is taken after defacement of the printing matrix to confirm the cancellation (see page 75)

Cancelling when the full edition has been printed the matrix is cancelled by scratching, drilling or chemical action. Litho plates and screen fabrics have the image completely removed so that the plate or screen can be re-used

Catalogue raisonné a scholarly catalogue which should include all the known works by an artist at the time of compilation. Essential information by which works are identified

Cellocut sheet celluloid dissolved in acetone is applied to a backing plate of heavy card or metal to build up layers which are printed on an etching press. Can result in embossing, relief or intaglio images with effects similar to collagraphs (see page 65). Invented by Boris Margo in the 1930s.

Chemical printing lithography (see page 22)

Chiaroscuro strongly contrasted areas of light and shadow in a picture

Chiaroscuro woodcut early form of colour printing in Europe using several blocks (see page 17)

China paper *or* **Chine** (*French*) fine strong paper originally made in China from mulberry bark. Used for relief and intaglio prints

Chine collé *or* **appliqué** (*French*) China paper backed by a stronger sheet, often of a slightly different colour. Used for intaglio prints: the pressure of the press unites the two damp sheets without adhesives

Chine volant (*French*) very fine Chinese paper like tissue

Chop mark blind embossed stamp in the corner of a print; denotes artist, printer or publisher (see page 110)

Chromiste (*French*) craftsman in intaglio or lithographic workshop who interprets a design, after an oil or gouache painting and creates the printing matrix on behalf of the artist

Chromo short for chromolithograph: a coloured lithograph of a commercial type

Chromolithography colour lithography; usually hand-drawn by someone other than the artist

Cibachrome trade name for a colour photographic system. Occasionally used by artists (see page 57)

Cliché verre (*French*) a sheet of glass is blackened and a design scratched through creating a drawn negative. This is used to print on photographic paper. Recently revived by artists in America

Collage block *or* **plate** printing matrices created by gluing *objets trouvées* or cut-out card, wood etc on to a backing plate: can be printed by relief or intaglio

Collagraph a print from a collaged block or plate. In America collagraph and collograph are both used (see page 65)

Collograph artist's print made by the collotype process (see Collotype). The artist draws each colour on a plastic sheet which is directly contacted with a light-sensitive, gelatine-covered plate. There is no half-tone screen nor any photographic intervention. Used experimentally by Henry Moore

Collotype derived from colloid: water-soluble gelatines, used to support a light-sensitive solution, with which sheets of plate glass are coated. When contacted with a negative and exposed to light parts of the gelatine harden. The plates are printed on lithographic-type presses which alternately ink and damp the plate. The hard gelatine accepts more ink while the soft gelatine accepts more water. No half-tone screen is required because the surface reticulation of the gelatine breaks up the tone into irregular textures

Computer print print originated by computer which is usually reproduced by screenprinting or lithography

Continuous tone light and dark rendered by variable density as in photographs

Copper-plate general term for all intaglio plates and prints

Copyright in printmaking, the copyright belongs to the publisher (who may also be the

artist) unless otherwise agreed. The basic copyright of the idea (rather than the finished print) remains the property of the artist

Coucher in hand-made papermaking the wet half-formed sheet is laid on felt sheets by the coucher

Counterproof a proof taken from one block or plate impressed on a new block or plate as a guide to position and registration

Crayon manner engraving an eighteenth century technique to create intaglio plates by means of roulettes and needles to look like a crayon drawing (see page 17)

Deckle the irregular edge of a hand-made sheet of paper. False deckles are made by tearing or irregular cutting. They· are easily distinguishable if compared

Deep etch very deep biting of an intaglio plate, sometimes right through the metal. Ink collects on the sides of the deep etched area and prints as a 'boundary' round the edge

Del *or* **delineavit** (*Latin*) lit. drew it. Seen on old prints following the name of the artist (see page 112)

Diazo lithography light sensitive compounds usually applied to aluminium litho plates and exposed to photographic or artist-drawn positives. No half-tone screen is required since tone is broken up by the combination of textures on the positive sheet and the grained aluminium. Also known as continuous-tone lithography (see page 69)

Direct 1 direct lithography (see page 51). 2 any work done directly on a printing matrix

Dolly see Poupée

Double Elephant a size of paper used by printmakers approx. 1020 x 690 mm (40 x 27 in)

Drypoint *or* **Pointe seche** (*French*), **Kaltnadel** (*German*) see page 64

Dotted print *or* **Manière cribblée** (*French*), **Schrotblatt** (*German*) fifteenth-century technique for engraving and stamping metal plates with punches. Occasionally used by artists today

Dye-line paper impregnated with light-sensitive solution used to make direct (positive) copies of plans or drawings. Soon discolours. Occasionally used by artists today

Dye transfer a form of colour photographic print giving great richness of hue. Occasionally used by artists today

Eauforte (*French*) 1 nitric acid. 2 generalized term for all etchings

Edition the total number of prints published and authorized by the artist offered for sale (see page 76)

Editioning the printing of the edition as opposed to the preliminary proofing

Editor's proofs a proof reserved for the editor who has organized the work on behalf of a publisher

Electrotype metal duplicate printing plate, often made from wood engravings, which are used to illustrate books and must stand up to a long printing run on modern presses

Embossing raised design in the paper surface. Damp paper is pushed into cut or etched plates and blocks, with or without ink. See page 65. See Gaufrage

Engraving cutting a design into wood (see page 60) or into metal (see page 64)

Epreuve d'artiste (*French*) or *EA* artist's proof

Estampe (*French*) 1 general term for an intaglio print. 2 used to describe a print from matrices made by a copyist after an original work

Estampe de tirage limité (*French*) a print drawn by other hands but issued in a numbered, limited edition which may also be signed by the originating artist (see page 33)

Estampille (*French*) 1 run-on after the edition is completed, not usually signed. 2 sometimes used to describe a print which relies largely on embossing

Estate print issued after the death of the artist. Usually identified by a special stamp and sometimes issued by the artist's widow or trustee

Etching 1 design bitten into a metal plate by means of acid (see page 48). 2 generalized term for all intaglio prints

Ex coll. (*Latin*) from the collection of . . . the provenance of a work of art

Excudit (*Latin*) lit. published it. Follows the name of the publisher of the print on old prints

Facsimile print fine quality reproduction of exactly the same size as the original

Feathering in etching, the use of a feather to remove bubbles from a plate in a nitric acid bath

Fecit (*Latin*) lit. made it. Follows the name of the maker of the print on old prints

Filigrane (*French*) watermark (see page 110)

Film 1 transparent plastic sheet used as a carrier for photographic emulsion. 2 grained transparent plastic sheet used by artists to draw/paint upon as an aid to registration of colours or to make a positive

Flocking powdered wool or other fibres stuck on a print with glue or varnish

Formed paper print paper pulp manipulated by an artist, or under an artist's supervision. Often of irregular shape, incorporating other materials, dyes and with further printing added after the sheet is dry (see page 59)

Formfschnider (*German*) artisan who cut a woodcut or engraving following an artist's design

Foul bite in etching when the mordant (acid) penetrates the acid-resist or ground unintentionally. Sometimes used deliberately to give a grainy texture

Four-colour half-tone the most widely used method of colour reproduction whereby a full range of colours is suggested by the optical illusion of printing in magenta red, turquoise blue (cyan), yellow and black half-tone dots (see pages 67 and 71)

Fourdrinier machine-made paper this was invented in 1798 and uses an endless web of wire cloth on which the pulp is formed into paper which is subsequently cut into sheets

Frame 1 rectangular structure to protect a picture. 2 rectangular structure on which fabric is stretched to make a screen to support a stencil in screenprinting. 3 the structural elements of a press

Frontispiece illustration in a book opposite the title page

Frottage (*French*) see Burnishing

Gaufrage (*French*) embossing. Used in particular to describe the embossing in traditional Japanese wood-block prints where the paper is pushed into the engraved block by the end of a brush or a pointed piece of wood

Glass print 1 see Cliché verre. 2 relief or intaglio print on thin paper stuck on to the back of a sheet of glass. Sometimes the paper was peeled off leaving the printing ink image and colour was added by hand

Graver engraving tool, for cutting wood or metal, sharpened to various angles producing different shaped cuts

Gravure (*French*) general term which includes all artist's prints, not only engravings, and is also frequently used for reproductions

Gum 1 gum arabic solution is used to desensitize litho plates. 2 gum tragacanth is used by gilders under the gold leaf. 3 generally of any glue; to be avoided in mounting prints

Gummed tape 1 kraft paper strip and animal glue used to seal parts of the screenprinting frame. 2 used to seal the back of picture frames, should be avoided (see page 101)

Half-tone tones rendered by small, variable-sized dots obtained by inserting a cross-ruled screen in front of a negative in a camera. Can be used by all printing methods; usually associated with mechanical reproduction

Hand-made paper paper made by hand in single sheets having a deckle edge along all four sides (see page 108)

Hardboard cut an engraving into hardboard (Masonite) which is made of pressed cellulose pulp with a hard finish

Hard ground mixture of wax, bitumen and resin which is coated on an etching plate to resist acid (see page 62)

Heat cutting the use of oxyactalyne or other gas torches to cut a design into intaglio plates (see page 65)

Heliogravure (*French*) 1 photogravure or photographic intaglio rotary printing used mainly for magazine printing. 2 a technique for making photo-etched plates using an aquatint texture directly on the plate, instead of the half-tone system to break up tonal areas. Used by Rouault in his series *Miserere*, 1948

Holzschnitt (*German*) woodcut

Hors commerce *or* **HC** (*French*) prints outside the edition offered for sale. Usually those for the publisher and collaborators for reference only (see page 77)

Imperial a size of paper used by printmakers approx. 560 x 760 mm (22 x 30 in)

Incunabula (*Latin*) those early European printed books produced from the invention of printing with moveable type up to 1500

India paper fine strong paper originally made in India. Used for relief and intaglio prints and book repairing

Insurance copy some publishers have one or two extra copies printed to substitute in case of damage: a recent practice adopted by mail order print publishers

Intaglio see page 48

Invenit (*Latin*) lit. designed it. Follows the name of the designer of the print on old prints

Impression 1 pressure applied to transfer ink from block or plate to paper; leaves indentation in intaglio and some relief printing. 2 synonymous with any proof or pull

Impressit (*Latin*) lit. printed it. Follows the name of the printer on old prints

Jésus (*French*) a size of paper used by printmakers approx. 500 x 720 mm (22 x 28½ in)

Jig-saw blocks and plates metal, wood, board or card blocks or plates cut up into pieces. Each part is inked in a different colour and the whole reassembled to be printed together. Used in relief and intaglio printing

Kento registration marks used in traditional Japanese wood-block printing consisting of an 'L' shape and a long strip of wood left along the bottom and one side of the block. The paper is placed to touch these two marks thus ensuring registration between blocks (see page 72). It is also used by Western artists in relief printing

Key block *or* **plate** where one colour carries the essential part of the design and is printed first so that subsequent colours are 'keyed' on to the first for accuracy. Occasionally the key design is not printed at all but is used only as a guide while making the printing matrices

Laid down a lithograph drawn on transfer paper is 'laid down' or transferred to a litho plate

Laid paper the impression of the mould wires in hand-made paper appears as closely spaced, light lines. The effect is reproduced on machine-made paper by a dandy roll

Lavis (*French*) wash effect in lithography (see page 68)

Letterpress 1 relief printing from type and blocks. 2 commercial relief printing

Levigator counterbalanced or hand-held device to hold the grinding stone when re-graining a litho stone

Lift-ground aquatint see page 63

Light-sensitive coating a coating on paper, metal, glass, plastic film or screen fabric which reacts to light by hardening in exposed areas. Used as (*a*) an acid-resist when etching photo-relief (process engraving) and photo-etching (photogravure); (*b*) as the grease-attracting image on a litho plate; (*c*) as screen mesh sealer for the non-printing areas in screenprinting

Limited edition a printing run usually of a previously declared number but this may be determined by the number of perfect prints obtainable

Line solid black and white drawn image in which no tone is used. Opposite of half-tone in commercial printing. High contrast or 'line' film is used to translate continuous tone photographs into black and white only. It is used by printmakers to avoid using the half-tone dot. See photo-litho page 68

Lineblock *or* **line-cut, -engraving, -etching, -plate** commercial printing terms for photo etched relief blocks for letterpress printing which consist of lines and solid areas only: without tone (see Process engraving)

Linocut, Gravure sur linoleum (*French*), **Linolschnitt** (*German*) linoleum engraving (see page 61)

Lithography see page 51

Lithotint nineteenth century technique imitating a wash drawing

Maculature (*French*) a second impression taken from a block or plate, without re-inking, to

remove excess ink. They sometimes appear for sale as do other working proofs

Manière criblée *(French)* see Dotted print

Manière noire *(French)* of any printing matrix which is first treated to print solid black; the design is then burnished, scraped or dissolved out to print in various tones: *(a)* mezzotint: plate textured with a rocker (see page 64) *(b)* aquatint: plate textured with aquatint ground (see page 63) *(c)* lithograph: plate rolled up solid with litho ink (see page 68)

Masonite cut see Hardboard cut

Master printer a skilled printmaking specialist, often working with an artist (see pages 78–80).

Mat see Mount

Mat burn discoloured area of paper beneath a window mount or mat usually caused by the chemical impurities in the mount or the bleaching of the exposed part of the picture (see pages 96–104)

Matt/mat dull finish: applied to printing inks or paper

Matrix the printing surface: block, plate or stencil

Mechanical screen a pattern on transparent material placed between an original and the negative in a camera. This breaks up continuous tone into dots, lines or irregular grains (depending on the pattern of the screen) to render tone in terms of black and white. The most common screen is the regular half-tone dot (see page 71)

Medium 1 in printmaking the main methods: relief, intaglio, lithography and screenprinting (see page 44). 2 substance which binds pigment in paint or ink

Mezzotint, Manière noire *(French)* **Schwabmanier** *(German)* see page 64

Mixed media prints which combine more than one media: lithography and screenprinting; embossing and lithography (see pages 58–59)

Merged colours see Blended colours

Metal cut early engraved metal plates printed relief

Monotype or monoprint the artist paints on a sheet of metal or glass with oil-bound colours and a sheet of paper is laid on top. It is either burnished by hand or put through a press transferring the image to the paper. As a subsequent impression will be weak, unless re-painted, monotypes are not considered to be artist's prints

Mordant acid used in etching

Mount rigid paper board used to protect prints. Ideally should be made from acid-free pulp. Known as the mat in America. May be used as backing or with a 'window' cut out to frame the work (see pages 98 and 100)

Multiple editions more than one edition of the same print. Usually on different papers and in different edition sizes, i.e. first a small edition on a rare paper; a second edition, larger, on mould-made paper; finally a mass edition on machine-made paper and often signed in the plate

Needle *or* **needling** in line etching a needle is used to draw the design through the hard ground to expose the metal beneath before it is put in an acid bath (see page 62)

Negative 1 the result of exposing glass or film coated with a light-sensitive emulsion to light. The silver salts in the emulsion darken in proportion to the intensity of light. From this a film positive is made. 2 indirect working (see stopping out)

Number of plates, blocks *or* **screens** number of matrices used; do not necessarily coincide with the number of colours or printings (see pages 66–67)

Objet trouvé *(French)* any found object which can be inked and printed. May be natural e.g. leaves, bark or man-made e.g. fabric, metal, plastics. Must be flat. See other relief blocks on page 61 and collagraph page 65

Offset short for offset lithography (see page 51)

Oleograph early colour lithograph simulating an oil painting

Open bite in etching where wide, shallow areas of the plate are bitten. Shallower than deep biting. The printing ink clings to the sides of the bitten image but the bottom is wiped almost clean of ink

Paper three basic types of paper are used in

printmaking: (a) hand-made. (b) mould-made. (c) machine-made. See pages 108–109

Papier vélin (*French*) wove paper; without laid lines

Papier vergé (*French*) see Laid paper

Passed for press written on a proof which is to act as the model when printing the edition (see Bon à tirer)

Peau de crapaud (*French*) 'skin of a toad': the peculiar texture in wash lithography with very fine wrinkle effect

Perspex or Plexiglass trade names for transparent plastic sheet used to engrave on, as a substitute for glass and to make boxes to hold prints

Pinxit (*Latin*) lit. painted it. Follows the name of the painter underneath the print on old prints

Pirated copy an infringement of copyright. Durer thought that some of Raimondi's engravings after his woodcuts amounted to pirating

Photo-etching see page 63

Photogravure 1 photo-etching on a commercial printing scale where the plate is in cylinder form (see heliogravure). 2 used increasingly as a term by artists for intaglio prints produced by photo-etching (see page 63)

Photo-litho see page 68

Photo-mechanical a broad term for any reproductive process which used photography to create the printing matrix

Photo-stencil used in screenprinting (see page 70)

Plate mark the indented edge of a block or plate in the paper. Characteristic of all intaglio prints. A false plate mark is the blind embossing of a rectangle to create an imitation mark. It was used in the past to deceive but is now being revived as an artistic device on relief prints, lithographs and screenprints

Pochoir (*French*) hand stencil using water or gouache colours applied by brush or sponge. The stencils are usually cut from thin sheet zinc. In the nineteenth and early twentieth century colours were added by pochoir on to pre-printed litho or collotype designs. Technique used for *Jazz* by Matisse, 1947 and is still used in conjunction with collotype for some facsimile

reproductions. Occasionally used by artists today

Positive 1 a photographic image giving natural representation of light and shade, monochrome or colour. If the support is opaque (paper or metal) it is a photographic print; if transparent (glass or film) it is a transparency or film positive. 2 direct working as in sugar-lift aquatint (see page 63)

Poupée (*French*) the twist of cloth or stick of felt used to colour by hand selected areas on printing blocks or plates (see page 67)

Pressure gap gap between glazing and print in framing (see pages 99 and 100)

Print cabinet anglicization of the German *Printkabinett*. Term for a print collection such as that found in a museum

Printed by hand sometimes written on a print or embossed by a chop mark to indicate that it has been printed by the artist. Not widespread

Printer's proof the copy of the print which is made for the printer's records

Printing order the order of printing colours. Very important (see page 74)

Process engraving the process of making photo-mechanical half-tone blocks, monochrome or three and four colour systems for letterpress printing (see half-tone)

Progressives series of proofs taken to show each individual colour and in combination (see illustration on page 67)

Proof or proofing the taking of a trial impression.

Provenance history of ownership of a work of art

Publisher the person who issues and sells prints and artist's books

Publisher's proof a copy for the publisher's records

Pull an impression taken at any stage of the printing process before editioning

Pulp from which paper is made, usually in sheets or webs (see page 108)

Radierung (*German*) etching (see page 48)

Rainbow colours see Blended colours

Raisin (*French*) a size of paper used by print-makers approx. 500 x 650 mm (19¾ x 25½ in)

Relief see page 45

Re-strike reprinting of a plate, often unauthorized, unsigned, after the artist's death and in unlimited quantity

Right to print *or* **RTP** see Bon à tirer

Recto right hand page in a book

Register the correct positioning of different colours in relationship to each other in a print (see page 72)

Reproduction process of duplication of an original painting, drawing or watercolour by photo-mechanical means or by a copyist (chromiste). Not artist's original prints (see pages 113–114)

Repoussage (*French*) to hammer up a defective part in a metal plate in order to re-work it

Retroussage (*French*) a film of ink left on the surface of an intaglio plate which prints as a pale colour overall

Reverse 1 an image which has to be worked back to front in order to print the right way round: all relief prints, intaglio prints and direct lithographs. 2 the back of a sheet of paper or metal

Rocker a toothed, hardened steel tool which is rocked back and forth over a metal plate to create a mezzotint texture (see page 64)

Roulette a small spiked wheel of hardened steel used to texture small areas of intaglio plates. Used in combination with etching, aquatint and drypoint. Also used to re-texture small parts on a mezzotint plate. Available in various sizes

Royal a size of paper used by printmakers approx. 510 x 675 mm (20 x 25 in)

Rubbing 1 when a sheet of paper is placed on a dry, incised or textured surface and crayon or waxy stick ink is rubbed over the paper. The lower surfaces of the object appear as white; the upper surfaces only give enough resistance for the wax to be picked up by the paper. 2 see Burnishing

Scorper a type of engraving tool used for wood engraving

Screen see page 54

Screenprinting see page 54

Sculpsit (*Latin*) lit. engraved it. Follows the engravers name on old prints

Second edition when a second edition is pulled from uncancelled blocks, plates or screens. It should be indicated as such but generally is to be discouraged (see page 76)

Separations 1 hand-drawn separations where an artist draws one sheet of paper or film for each colour to be printed. 2 photo-mechanical separations when the primary hues in an original are isolated by means of filters in a camera and serve as negatives from which printing plates are made

Serigraph or serigraphy screenprinting (see page 56)

Sieve print screenprint (see page 56)

Signature 1 the signature of the artist to indicate approval of a print. 2 groups of pages bound together in a book

Signed in the plate the signature of the artist incorporated in the matrix: the result is a printed signature therefore the artist has not given individual approval to each print

Silk screen screenprinting (see page 56)

Size 1 overall size of the paper. 2 size of the image. Generally given as height before width. 3 a gelatinous solution used in glazing paper

Soft ground in etching a hard ground with the addition of grease to make it soft (see page 62)

Solander box *or* **case** a case made in two parts one of which slides over the other in which to store prints, drawings and books. The back is often finished like a book spine. Generally made of board covered in paper and cloth (see page 105)

Stamp 1 to impress an inked or uninked block on to paper. 2 embossing stamp which clamps the paper between a male and female die and is impossible to eradicate (see page 110)

States working proofs in sequence used by the artist to judge the progress of the work (see page 74)

Steel engraving popular in the early nineteenth century to produce plates which could print very large numbers. The characteristic is a hard, precise line

Steel facing copper intaglio plates are covered with a thin deposit of steel by electrolysis. This hard surface allows a larger number of good prints to be taken before wear is evident. Invented in 1859, it was considered to be a form of falsification and many experts claimed that detail was coarsened, however it is now generally accepted

Stencil 1 screenprinting (see page 54). 2 design cut out of paper used to mask areas of a printing matrix during inking, used in relief and intaglio

Stipple etching and engraving. An intaglio print in which the design is created by dots only

Stone 1 lithographic stone: a slab of Bavarian limestone usually 2–4 in. thick, either cream or light grey in colour. 2 metal table on which type is arranged before printing

Stopping-out the use of various substances such as varnish, gum or sugar solution to protect areas of blocks, plates and screens from the action of acid, ink or other media

Sugar-lift see page 63

Surface printing printing from the surface of the plate in relief printing and intaglio colour printing (see page 66)

Title page page in a book or a collection of prints near the beginning which gives the title, artist and/or author and publisher

Tone separation eliminating all intermediate tones (see Line)

Transfer an image transferred from one material to another, mainly in lithography (see page 69)

Trial proof working proof usually experimenting with different colours and papers

Trimming prints cutting into the sheet of paper as first published. Not encouraged (see page 110)

Tusche (*German*) liquid lithographic drawing ink. Also used to draw directly on screen mesh

Unique impression single print from a block, plate or screen which is not repeated in that form: could be a trial proof or a proof of an abandoned image

Unlimited *or* **unrestricted edition** editions which are not limited or numbered though there may be a stated total print run

Unpublished plate a printing matrix so far not published. Often refers to a work found after the death of an artist which may be published posthumously

Vatman in hand-made paper the craftsman who lifts the pulp from the vat by means of a mould (see page 108)

Verso left hand page in a book

Waste sheets extra sheets of paper used during proofing or editioning which are used to set-up the machine or test registration. Not part of the edition. They are usually recycled in the workshop

Watermark design in the paper, seen when held against the light. Manufacturer's mark. Used to trace the origin of paper. Special makings for an artist or publisher may incorporate a signature or device (see page 110)

Woodcut see page 60

Wood engraving see page 60

Working proof proofs taken while developing the idea. Same as trial proofs

Wove paper paper without laid lines (see Laid paper)

Xylograph woodcut (see page 60)

Xerography trade name of one version of electrostatic printing which uses an electric charge to deposit pigment particles on paper. Monochrome and colour. Occasionally used by artists today

Zinc used for etching plates and letterpress line blocks though the last are now made from alloys

Zinco lineblock made of zinc or alloy

Zincography lithography on zinc plates, now an obsolete term

Acknowledgements

I would like to thank all the museums, galleries, artists and dealers who kindly supplied me with photographs for this book, without whose generosity it would not have been possible to illustrate such a range of prints.

R.S. 1980

Association pour la Diffusion des Arts Graphiques et Plastiques, 33: Bengt Bockman, 37 right: Barcham Green & Co. Ltd., 107: Chris Burnham, Chapter Arts centre, front cover: Christie, Manson and Wood, 11 right, 13 right & left, 14 right & left, 15, 16 right & left, 17, 18, 19 right & left, 20, 21 right & left, 23 top & below, 24 top & below, 26, 27 right & left, 28 right & left, 30, 31, 32, 85: Christie's Contemporary Art, 38, 41 below right, 42 right & left, 58, 60 top, 61 centre & below, 63 top & centre, 64 centre, 67, 68 top & centre, 70 top & centre, 79, 81, 103: Curwen Press, 47 below, 60 below: Curwen Prints Ltd, 40, 68 below, 69 top (reproduced by kind permission of Katherine Houthusen), 69 below, 115: Peter Daglish, 61 top: Factory Editions, 41 top right: Ganymed Original Editions Ltd., 111: Gemini, 7 below (sold at Sotheby's January, 1977), 35: Graffiti, 8 left: Guggenheim Museum, 9: Illustrated London News 1862, 25: International Arts Association, 101: Raimo Kanerva, 10 left (photo City of Bradford Museum & Art Gallery): Kelpra Editions, 11 right, 84: Cynthia Knapton, 65 centre (photo City of Bradford Museum & Art Gallery): Alena Kucerova, 65 top (photo City of Bradford Museum and Art Gallery): Akira Kurosaki, 62 top (photo City of Bradford Museum & Art Gallery): Landfall Press, 41 left: Leicester Education Committee, 8 right: by courtesy of Marlborough Fine Art (London) Ltd., 52, 69 centre, 71, 99: reproduced by permission of New Arts Centre, London, 64 top, 91 below: Petersburg Press, 6, 90: Liliana Porter, 10 right (photo City of Bradford Museum & Art Gallery): Redfern Gallery, 41 top left: Editions Denise Rene, 34: Rosemary Simmons, 61 below, 95: Birgit Skiold, 65 below (photo Thomas Simmons): Sky Editions, 53: Albert Skira, Paris, 78: Slade School of Fine Art, 36 above & above left, 37 left: Societé de la Proprieté Artistique et des Dessins et Modèles, 47 top, 80: Alyson Stoneman, 63 below: Studio Prints, 43, 64 below: Victoria & Albert Museum, 50, 55, 91 top: Steve Walton, 70 below (photo City of Bradford Museum and Art Gallery): William Weege, 59 (photo City of Bradford Museum and Art Gallery): Terry Willson, published by Michael Ashby Fine Art, 66 below, 99 (courtesy of Palm Tree Editions).